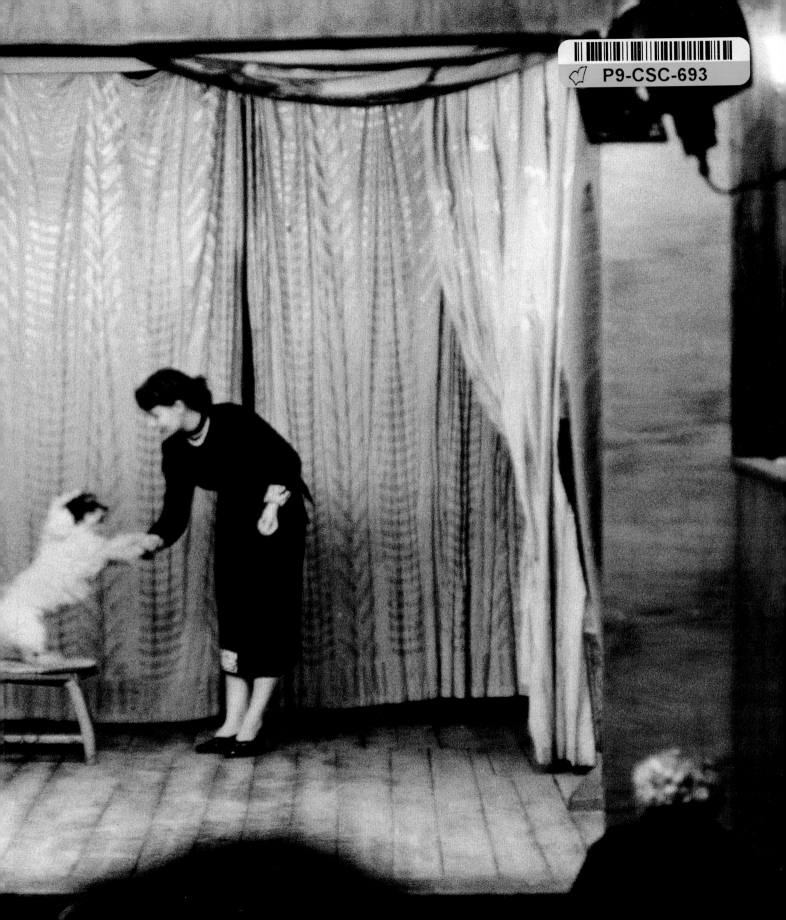

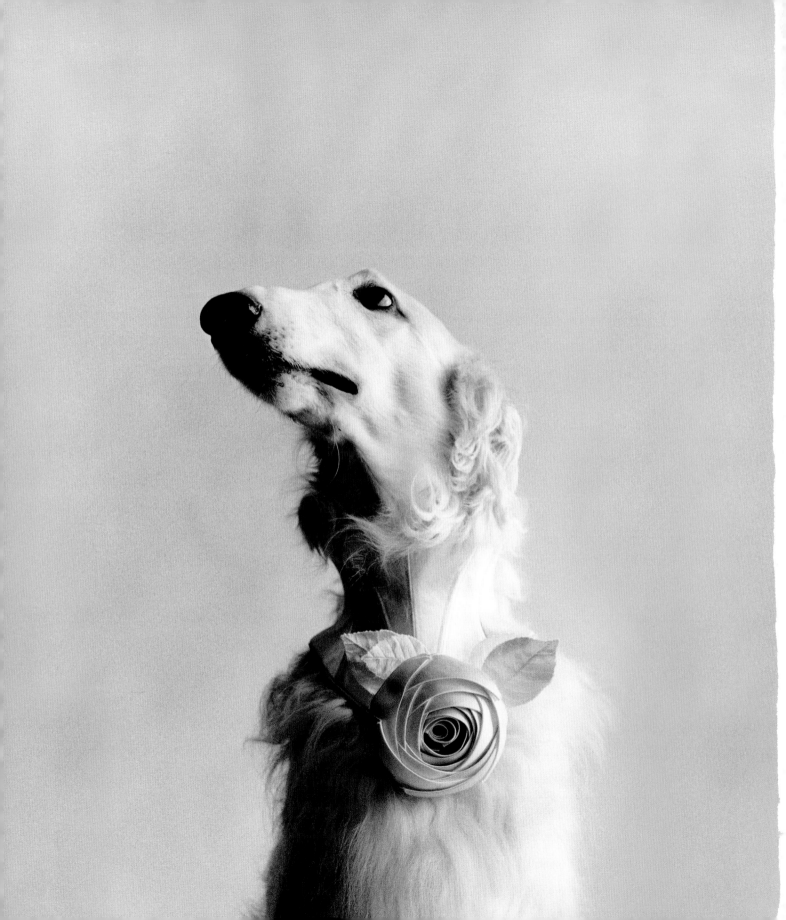

woof **elliott erwitt**

foreword by trudie styler

CHRONICLE BOOKS

SAN FRANCISCO

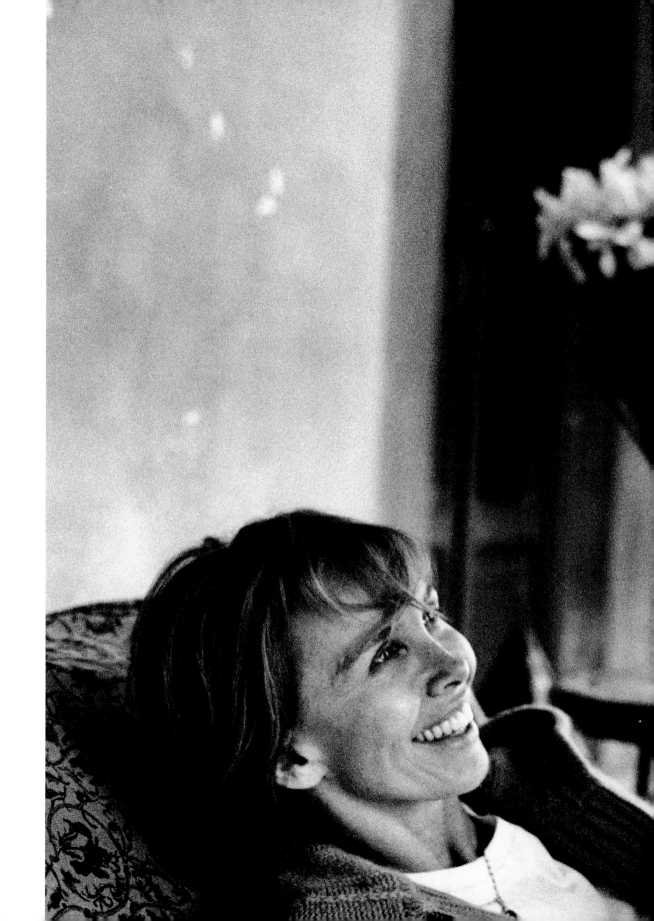

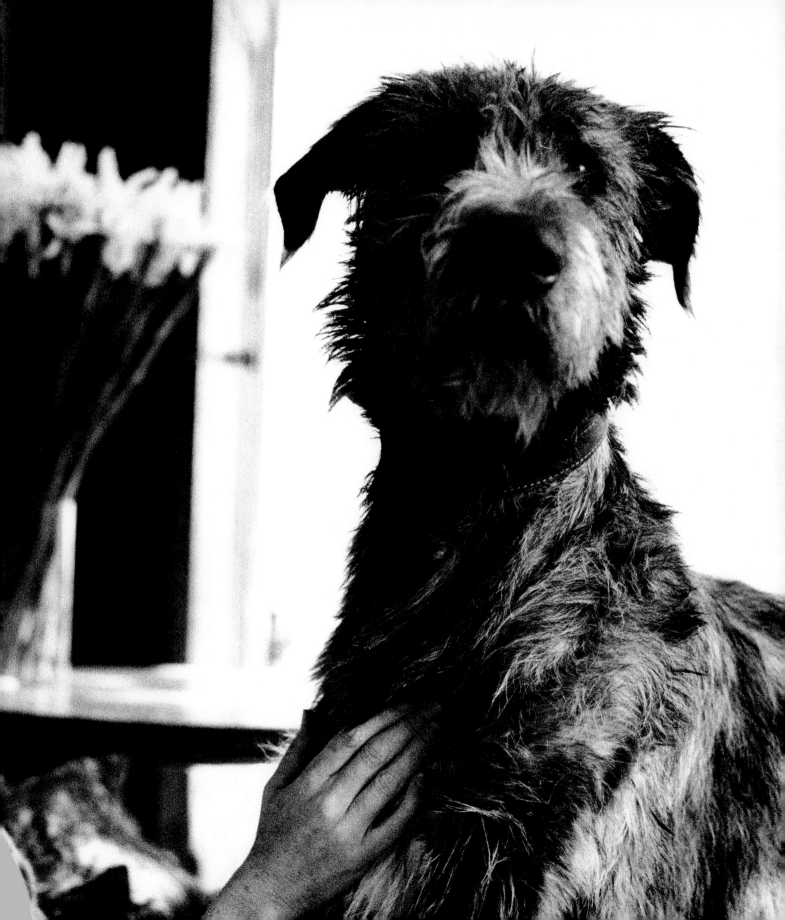

I felt greatly honoured when Elliott Erwitt asked me if I would write the foreword for another of his extraordinary books, the irreverently titled Woof.

Our mutual love of dogs brought Elliott and me together. When my husband, Sting, and I moved to New York for a short time — back in the bad old days when doggy passports hadn't been invented — my daughter, Coco, had to leave her beloved Labrador, Fred, back in England. I went in search of great dog pictures to cheer her up. There were none better than Elliott Erwitt's. If Elliott were a dog, for me he would be a pug. Not in looks, I hasten to add, but in character: ferociously intelligent; wry sense of humour; terminally adorable.

I never had a dog when I was growing up. My first dog experience was a puppy I bought for Sting when I was pregnant with our first child, Mickey. I wondered if Sting would be one of those men who feel like they're not getting enough attention once a baby is born, so as a distraction from potential baby jealousy I bought him a springer spaniel puppy. Willy came into our lives, and from then on everything changed.

Although he died in 1994, the legend of Willy lives on in our family. At only twelve weeks old we thought we'd lost him when we were checking out of a hotel in Scotland. Willy had been in our peripheral vision as we paid the bill, then suddenly disappeared. We'd been told the weather was closing in, so there was an urgent need to leave for the airport as soon as possible. But where was Willy? Not a sign of the twelve-week-old springer. I went outside calling his name, 'Willy! Willy!' Then something caught my eye. Willy had attached himself to a rather portly lady, and was dangling off the back of her fur coat. She was completely oblivious to him, and was about to get into her car and squish him with her very big, spreading rear end. Willy would have been done for, no question! Luckily I spotted him just in time and he lived to fight another day, and indeed another adventure-packed twelve years. Stories like that abound. Willy was always getting into scrapes, out of his sheer enthusiasm for life, his naughtiness, and his irrepressible inability to be trained. He was his own dog, and as such he commanded considerable respect.

Many years have passed since Willy left us, but since then we have always had dogs as part of the family.

Dogs are tremendous company. They are not just pets that you need to feed and exercise and take to the vet from time to time. A dog becomes, as the cliché says, one of your best friends. And not any dog will do either. As with people, sometimes you just 'click' with certain dogs. Sting loved Willy; he felt a deep psychological connection to him. I think he still misses him hugely. But the only other dog to whom he has had that same chemical attraction is Roo, the flat-coated retriever pictured in this book (pages 20–21).

Even though Sting travels so much, and Roo greatly misses him, whenever he comes home Roo is there to greet him like an old friend — exuberant, happy to see him, no questions asked. Roo just accepts that his master is home and his happiness is therefore complete. They just pick up exactly where they left off.

I think humans can learn an important lesson from the nature of a dog. A dog's life is complete when his master or mistress is there, but there's no criticism or judgment from the dog when he or she is away. They simply accept the love they are given without question; they don't harbour disappointments, or sulk, or impose expectations. At the risk of beginning to sound like a total dog fruitcake, it's a state of acceptance almost Buddhist in its

expression, an elevated state of grace. Most human beings find such acceptance and grace extremely difficult to achieve.

Your dog becomes a part of you, your familiar, and as such you invest a huge amount of love and emotion in your dog. My first canine love was an Irish wolfhound called Gideon. He was a dog of such exceptional beauty and kindness, with a great temperament, that when I had the opportunity to have his sperm frozen, I didn't hesitate. Four years after his death we had an extraordinary litter of puppies. I chose Mikey from the litter. He is very like Gideon, but also a wonderful wolfhound in his own right.

My enjoyment of wolfhounds has inspired me to breed them. At the news that one of my bitches was going to Crufts, that Great British doggy institution, I found myself behaving like a proud mom. It was almost like having one of my own children winning a great accolade!

The world needs more kindness, not less, and in those majestic, loyal, gentle giants there is a wealth of kindness and generosity. They are at their best when they are around children, and display extraordinary patience when they are pulled and prodded and ridden on, tolerating indignities far beneath their canine aristocracy with studied forbearance.

Myths and legends about the protective nature of wolfhounds abound, and we have had personal experience of their tremendously clever and caring natures. When my housekeeper Noel was walking two wolfhounds one winter, she slipped and fell on the ice, twisting her ankle. The two dogs lay down on either side of her and waited.

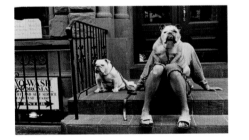
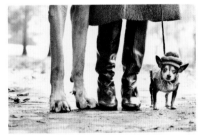

As she tried to get up, they slowly rose from the ground, providing support for her as she tried to find her feet once more. Then they flanked her all the way home, allowing her to lean on them, and never leaving her side.

For me, Elliott's photographs often convey the special nature of dogs, whatever the breed. I am the proud owner of some Elliott Erwitt photographs and a great admirer of him as an artist. His images are wonderfully frank, often amusing interpretations of his subjects, and they gently encourage us to laugh at ourselves. He has a lightness of touch and great warmth when he pokes fun at human beings, and an evident respect for the dogs who befriend us. It seems to me that if there is a dog and a person in the same Elliott Erwitt photograph, the dog will often come out best.

And that should give us all something to ponder! — Trudie Styler

Every dog must have his day.

— Jonathan Swift

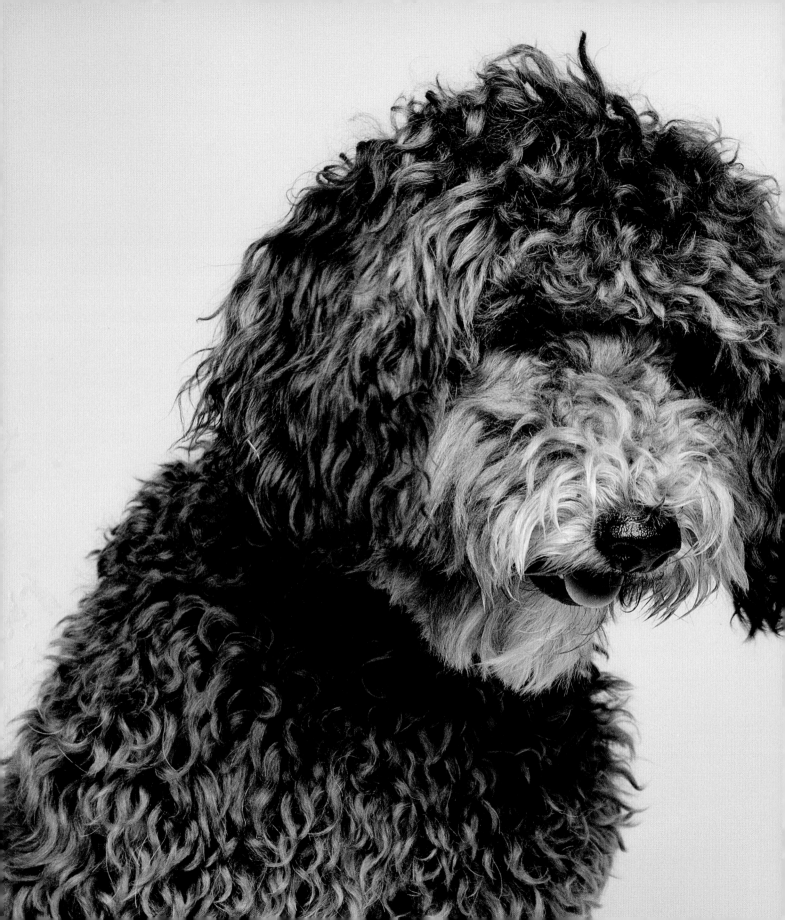

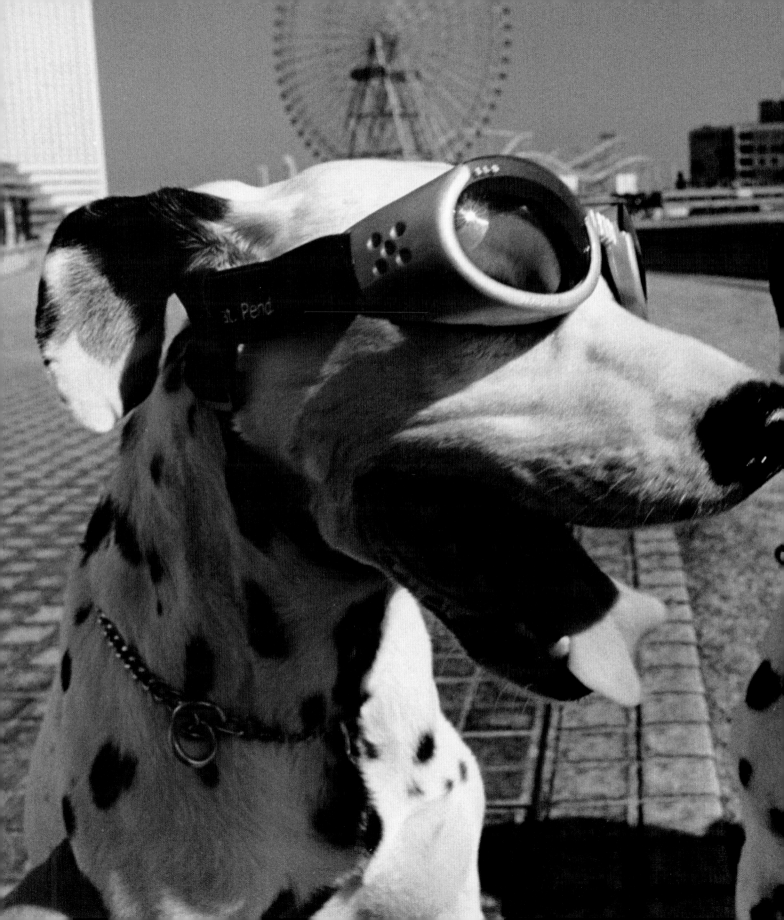

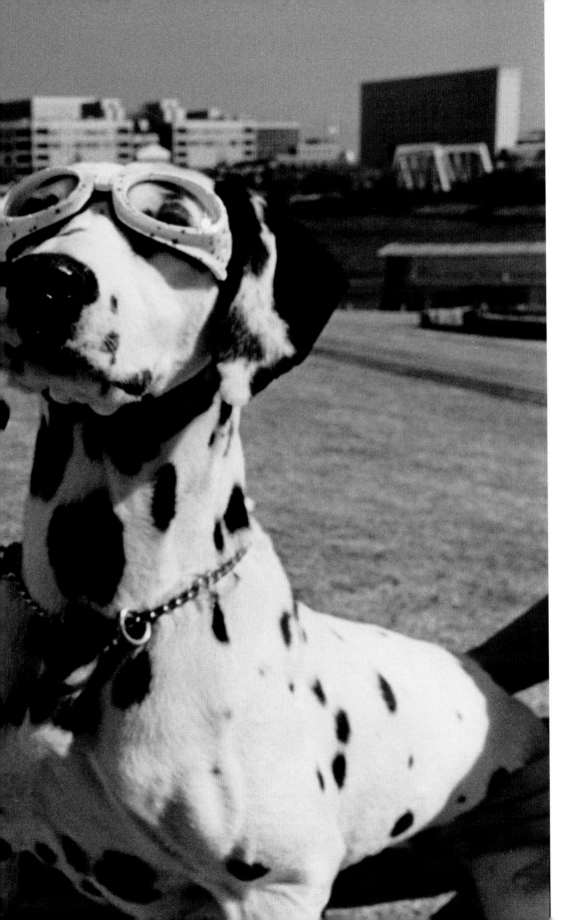

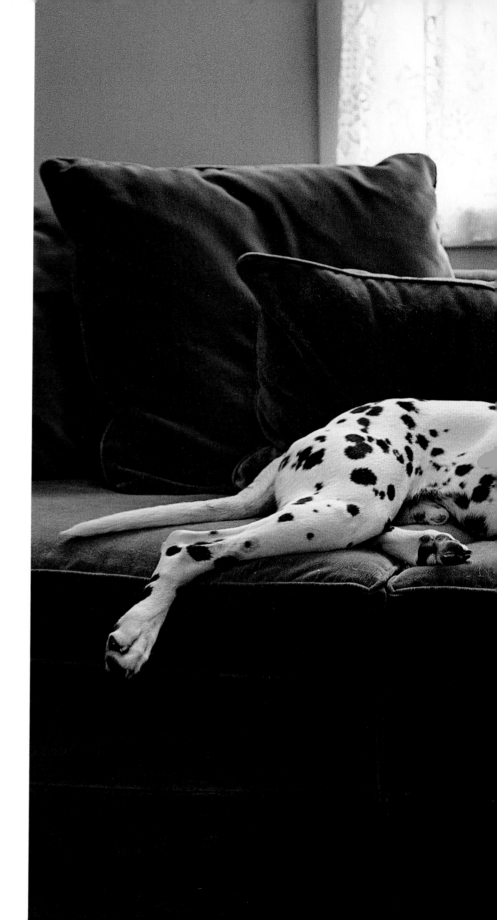

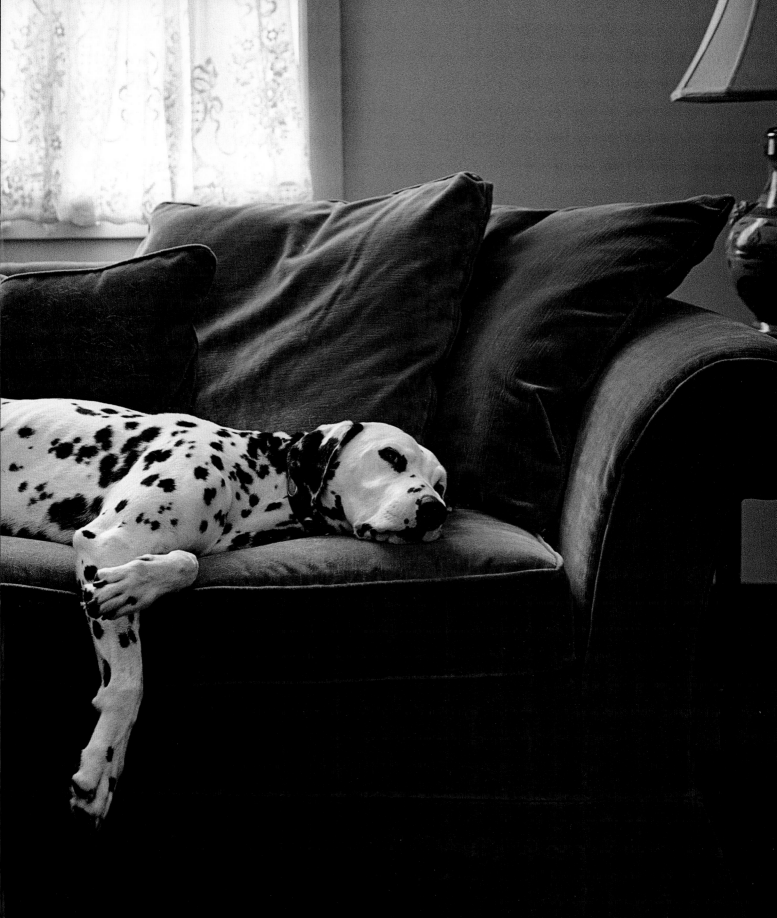

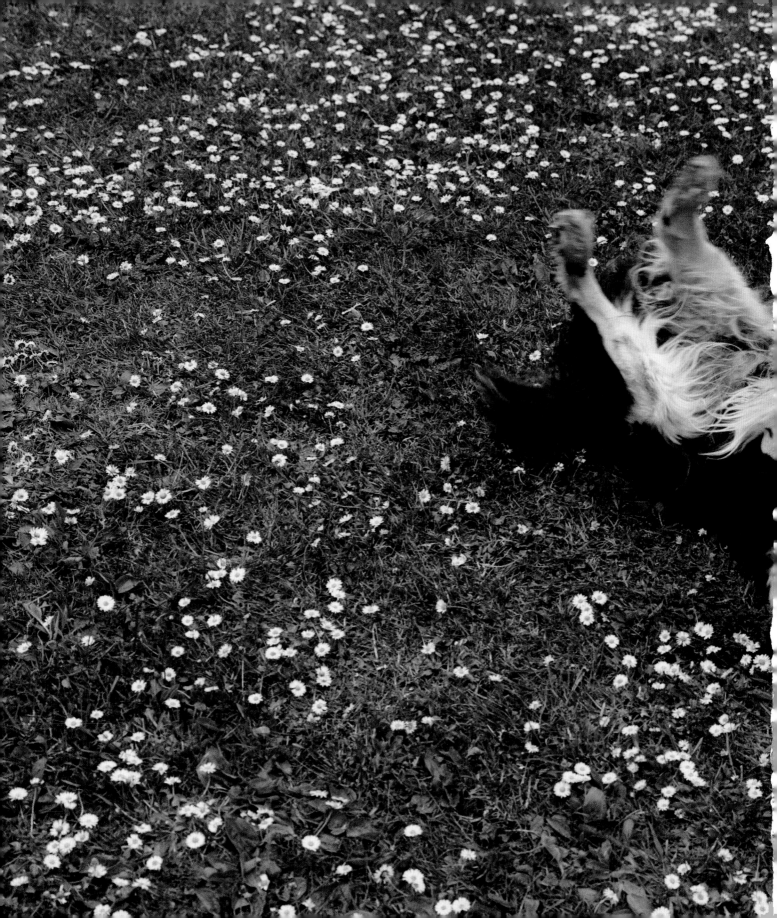

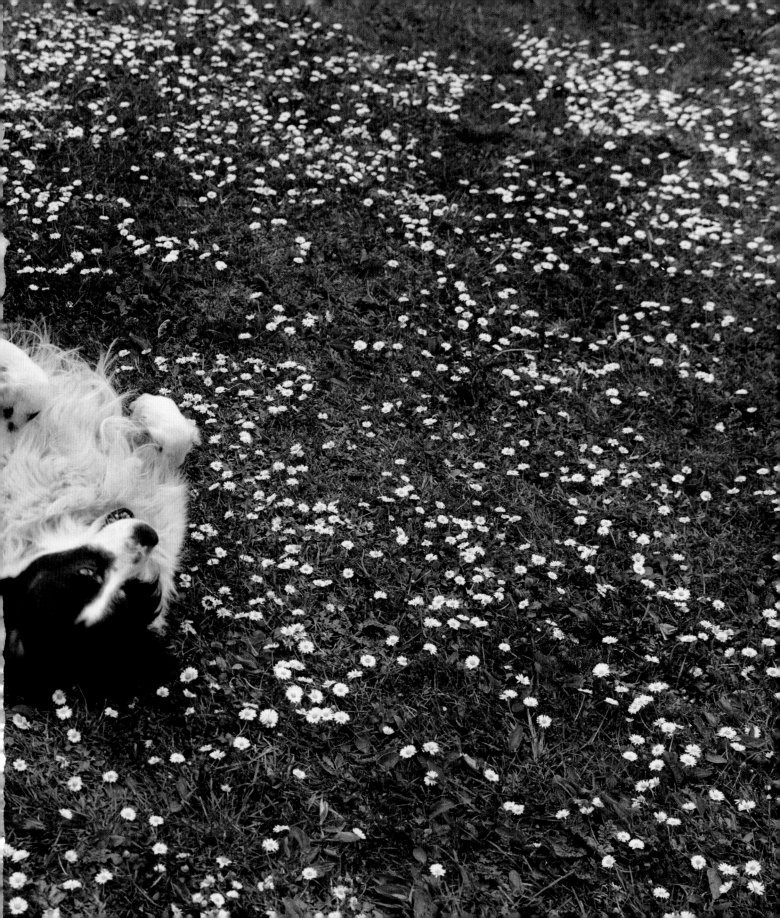

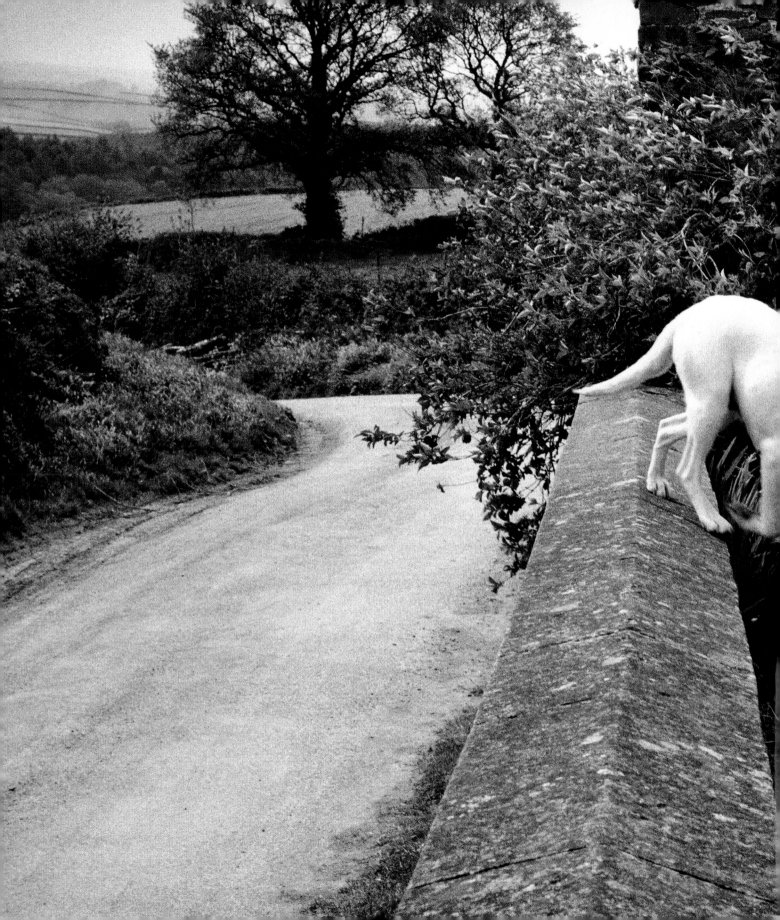

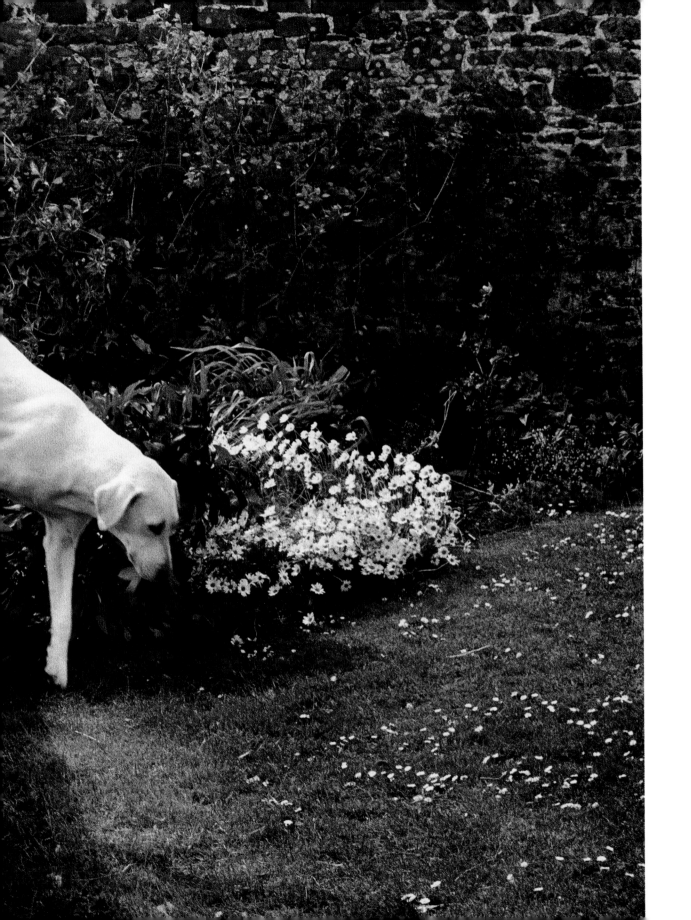

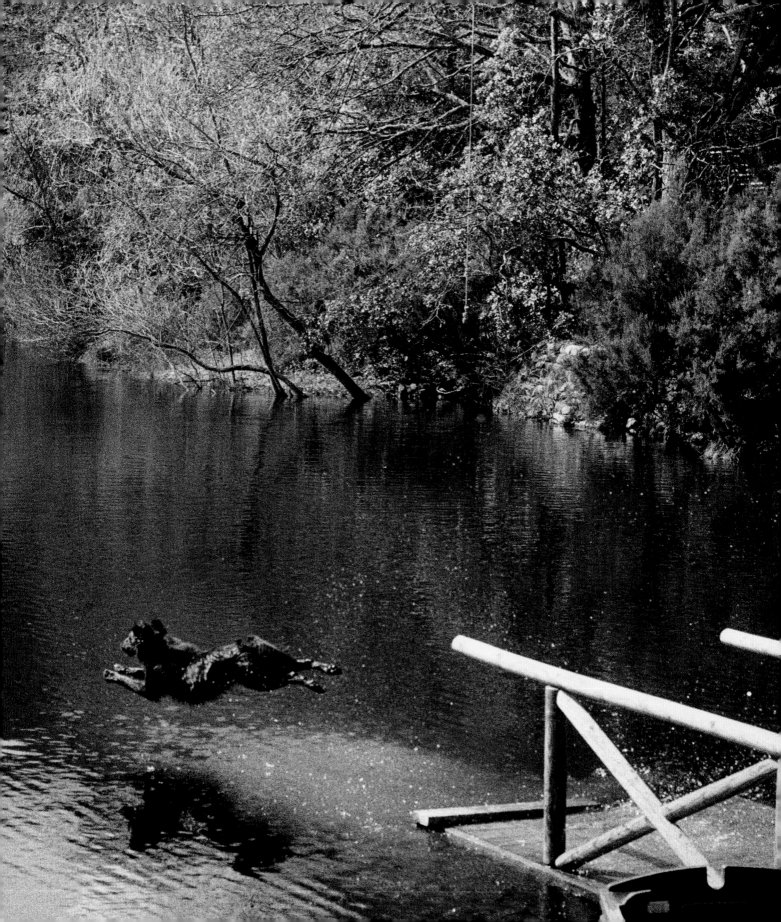

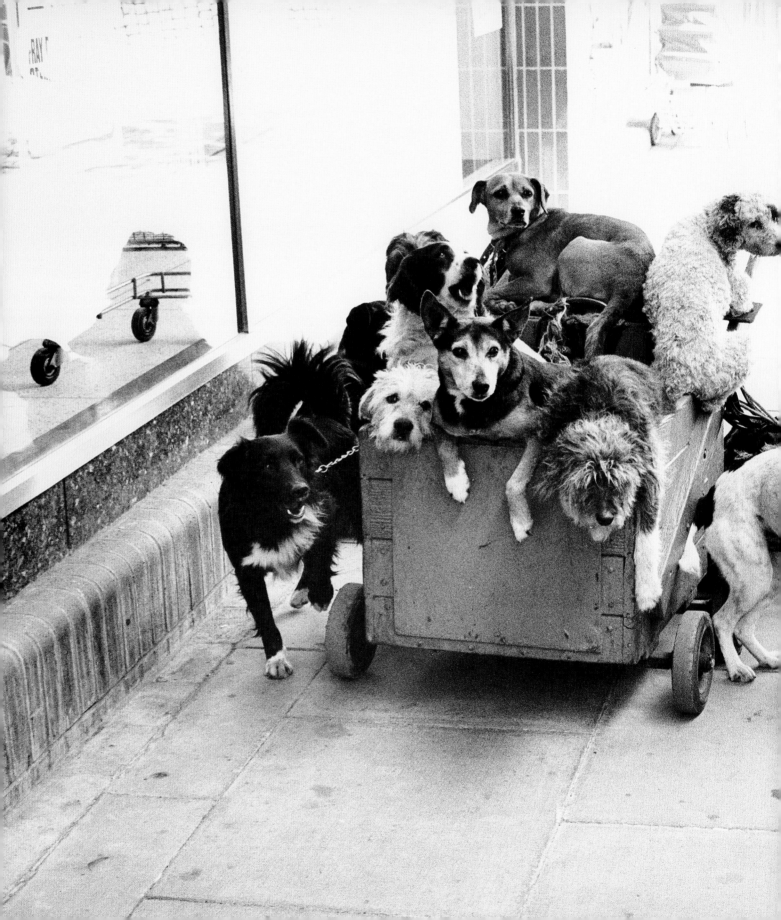

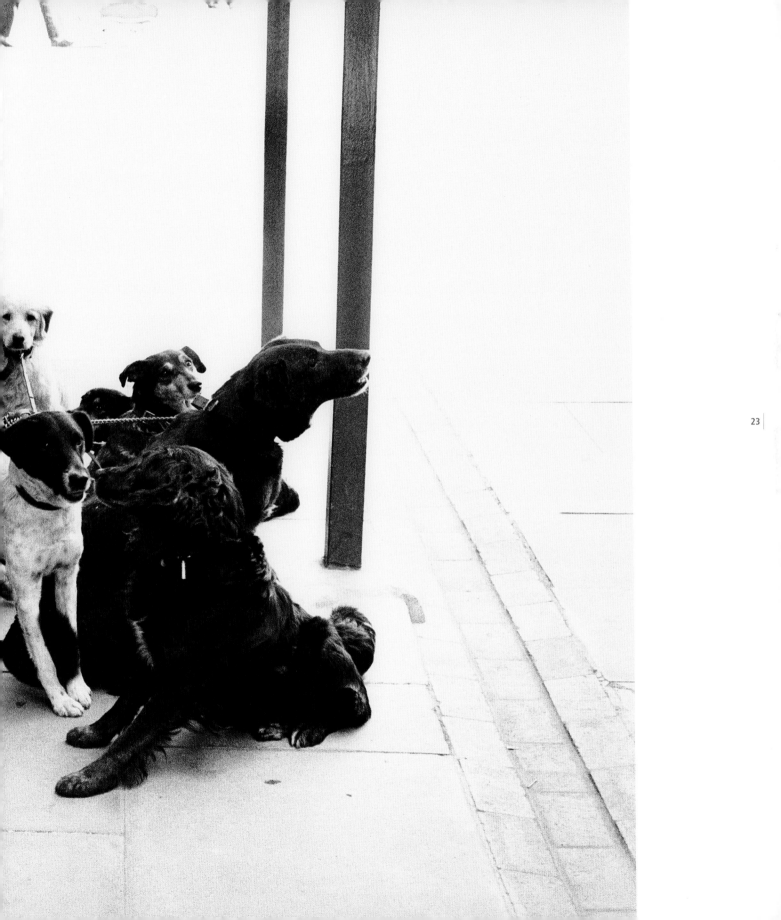

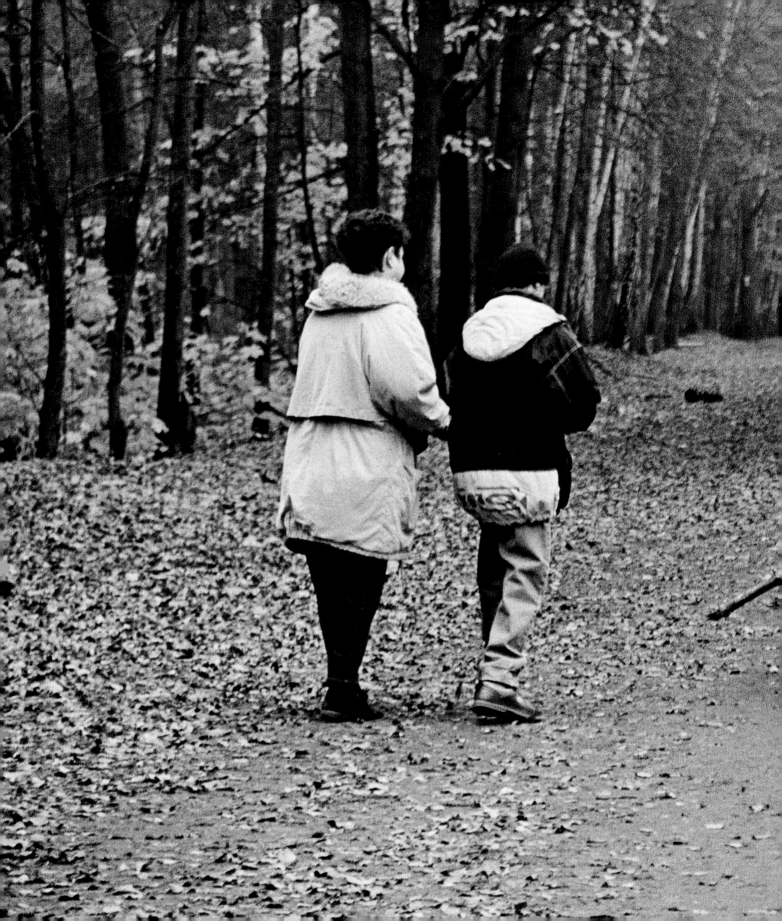

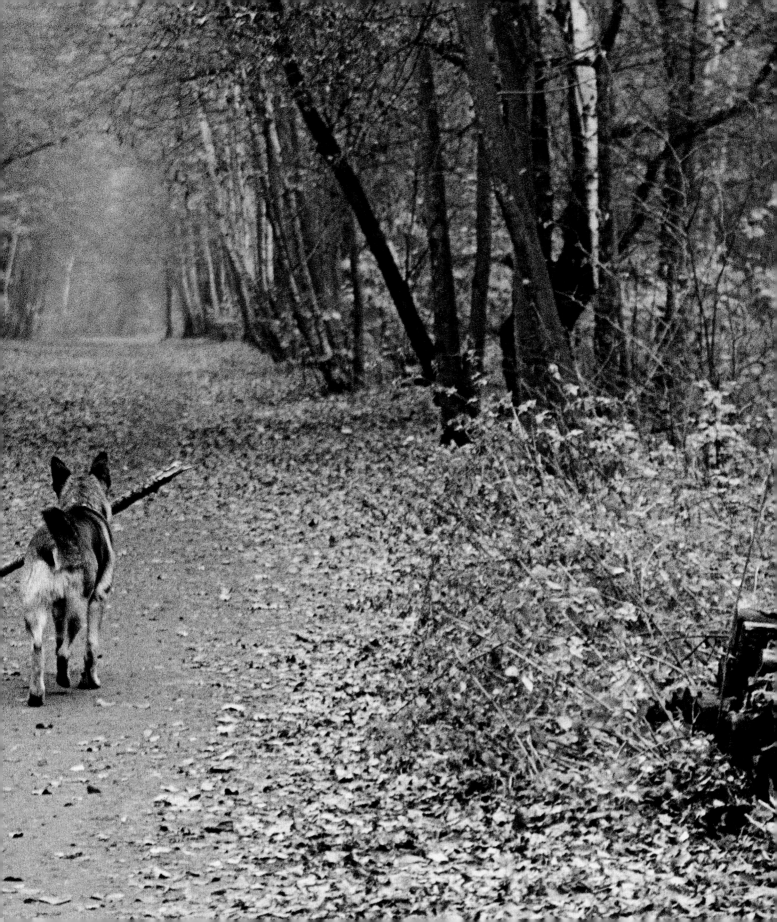

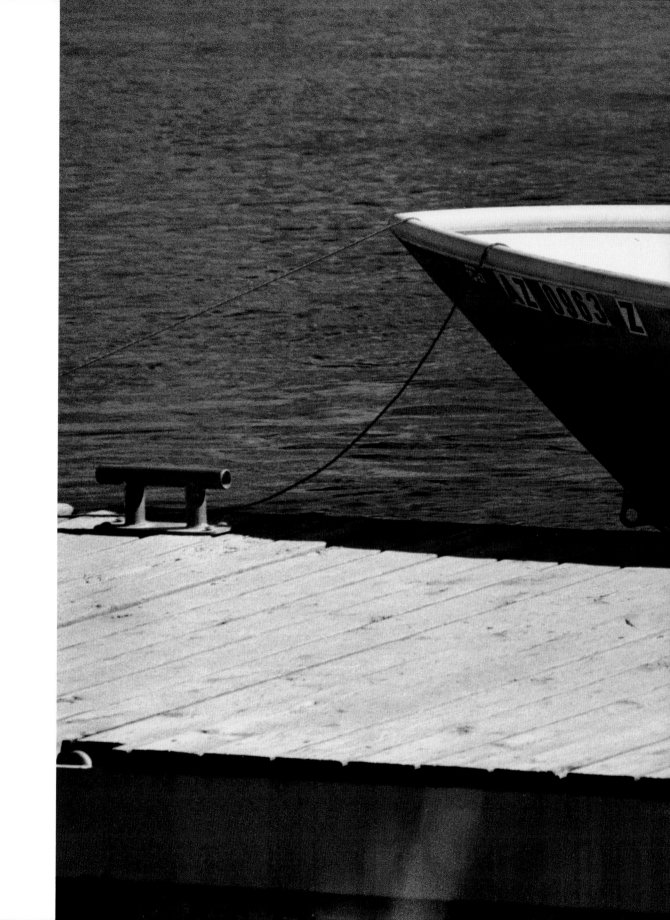

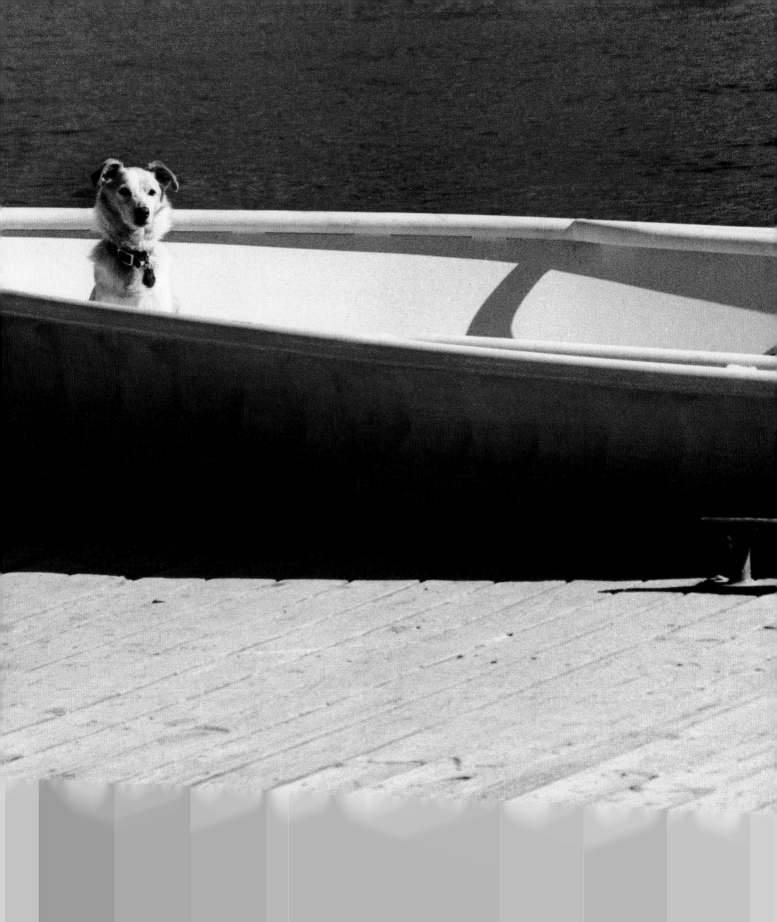

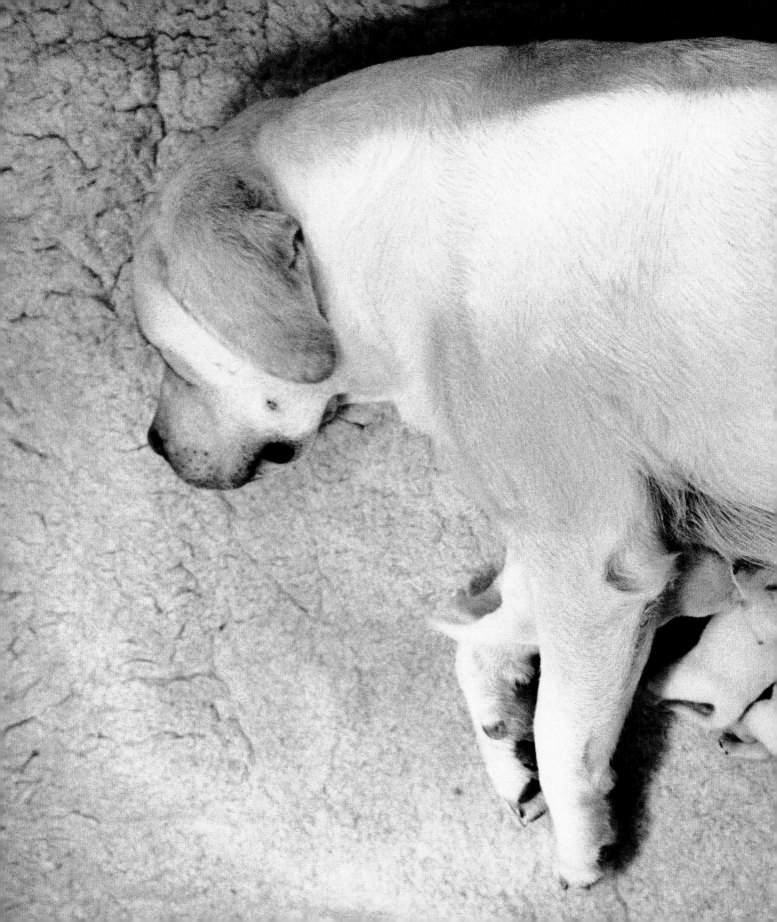

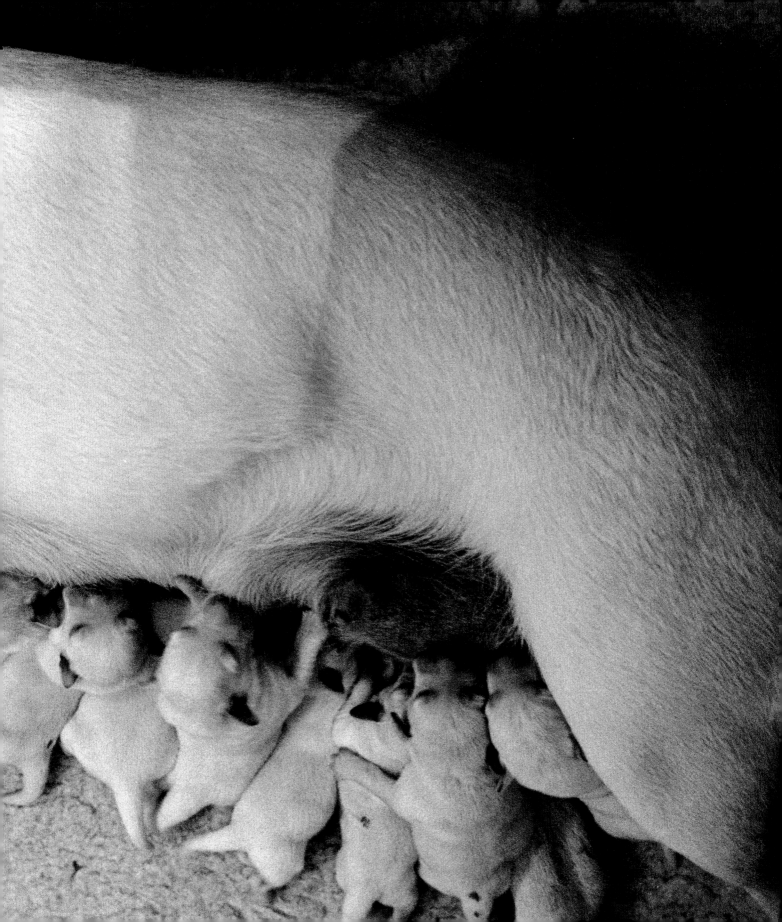

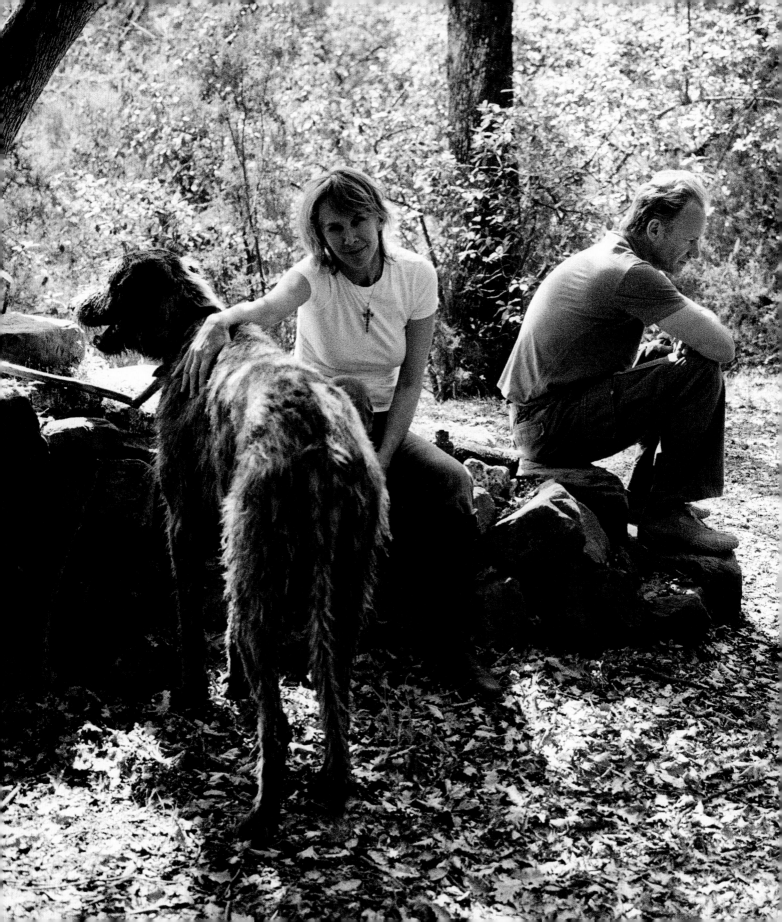

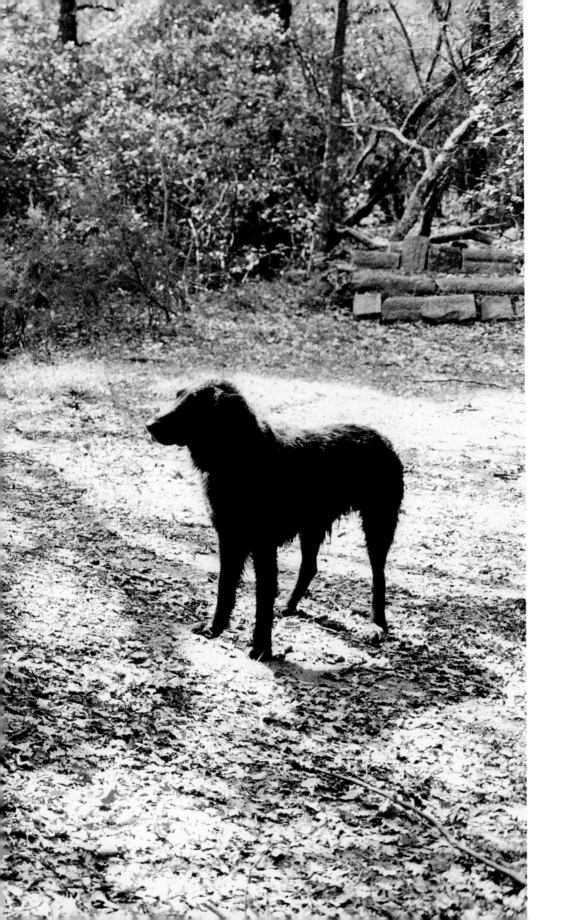

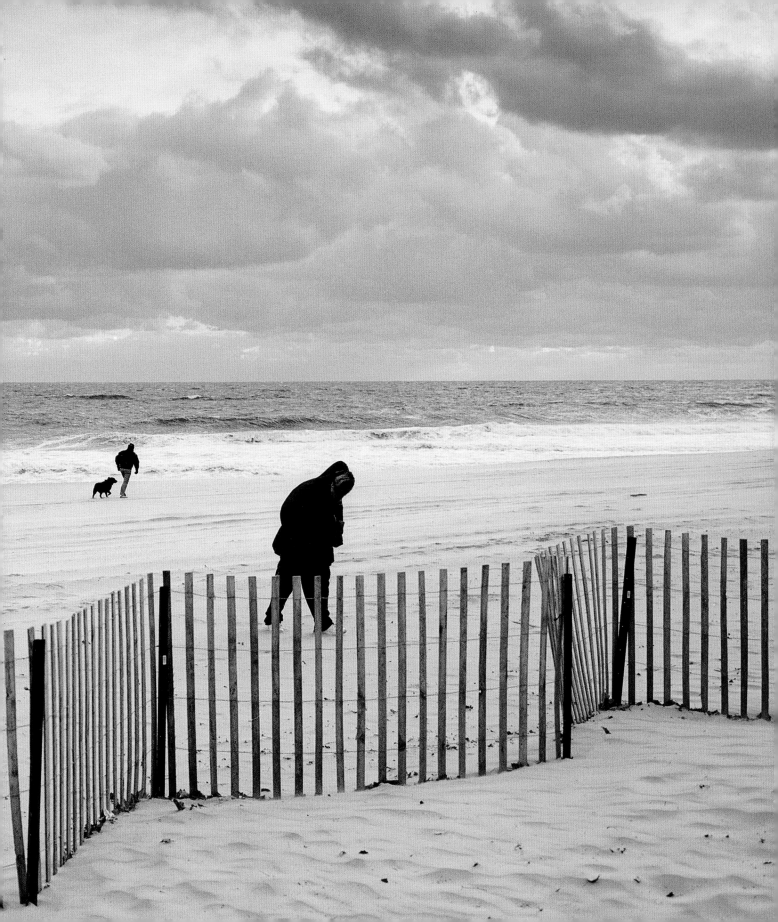

Dogs love company.

They place it first in their short list of needs.

— J.R. Ackerley

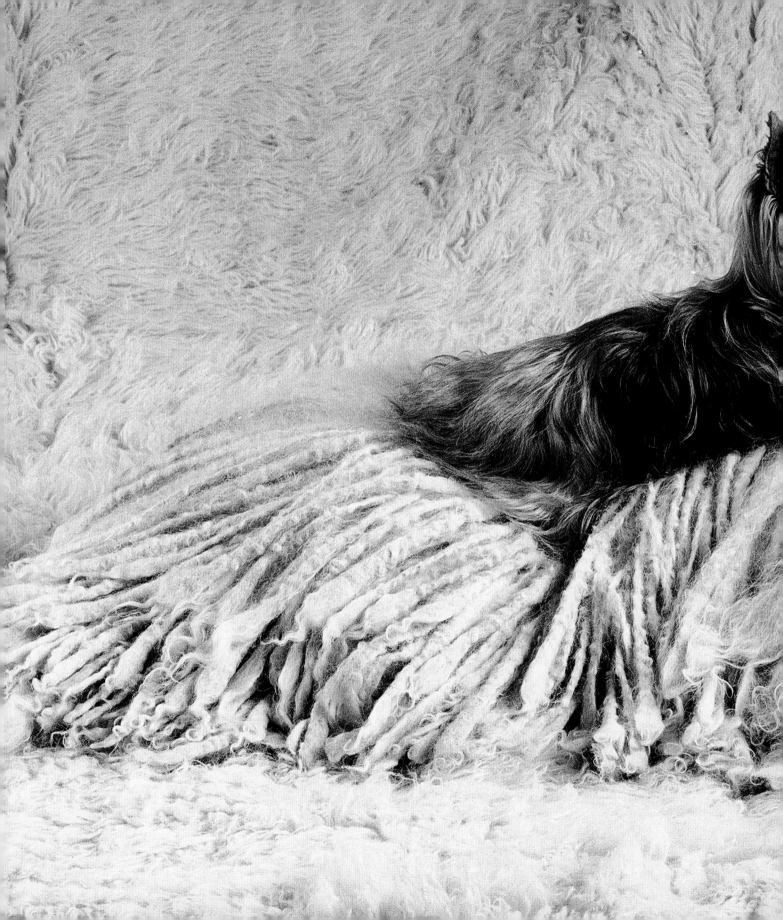

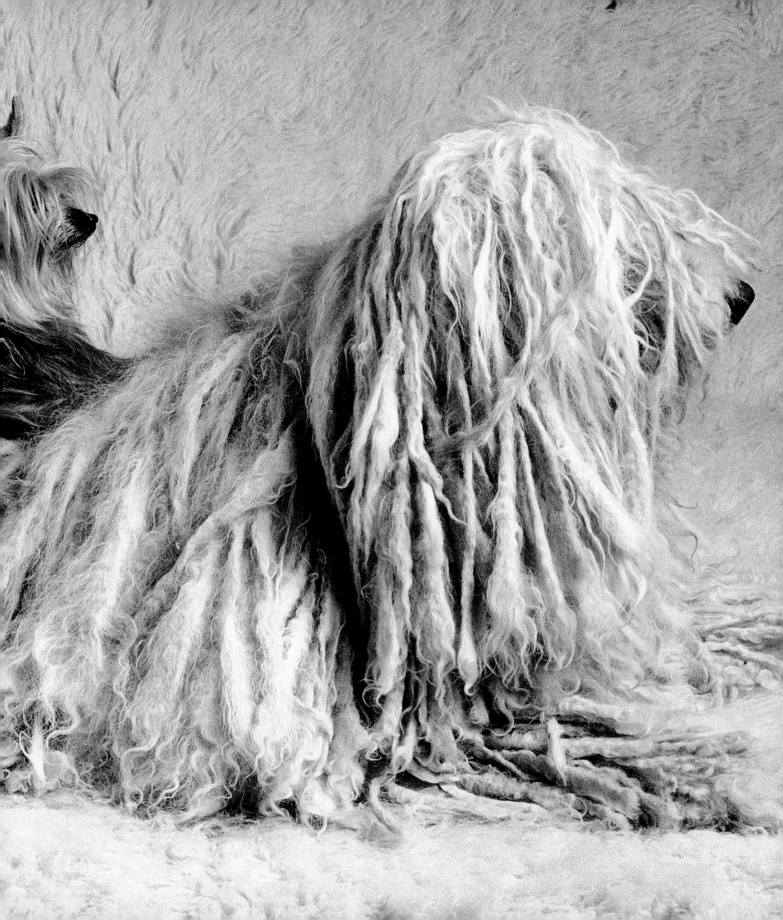

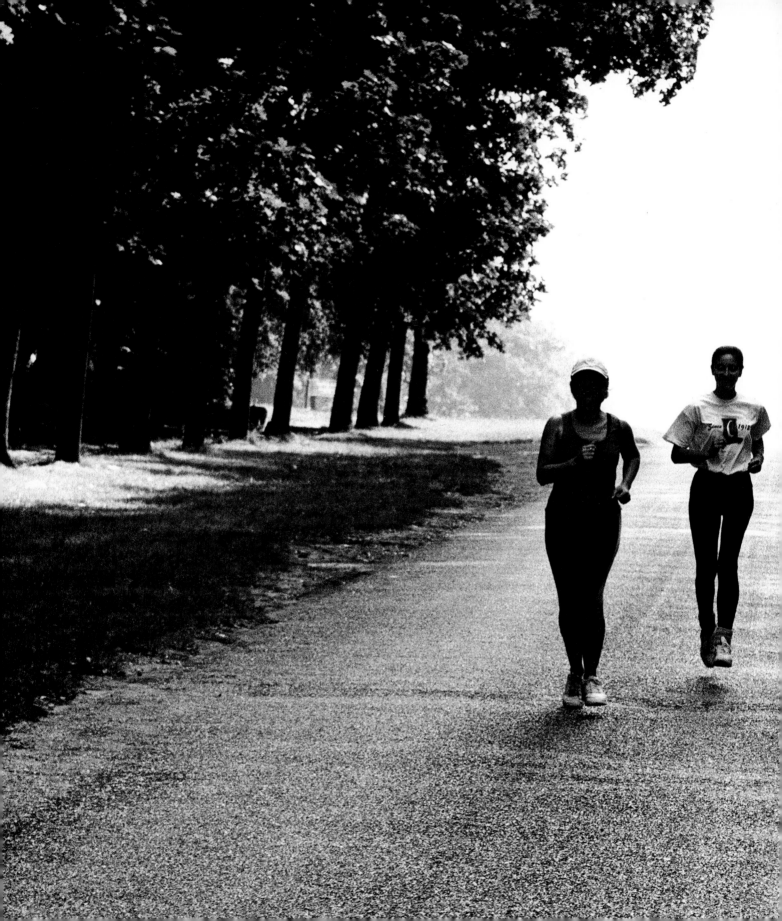

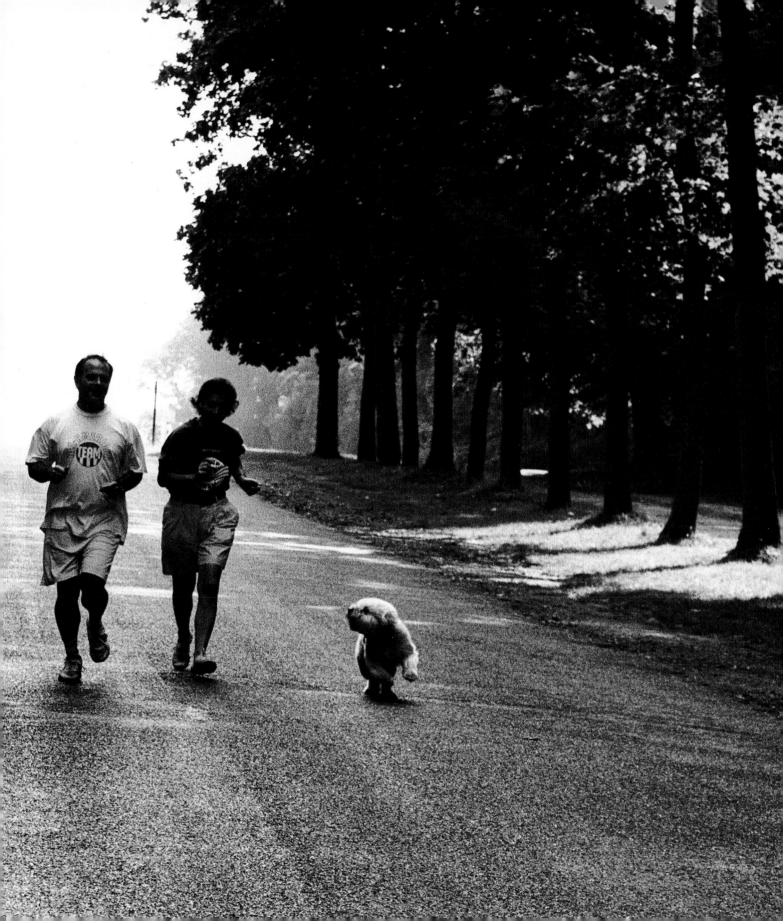

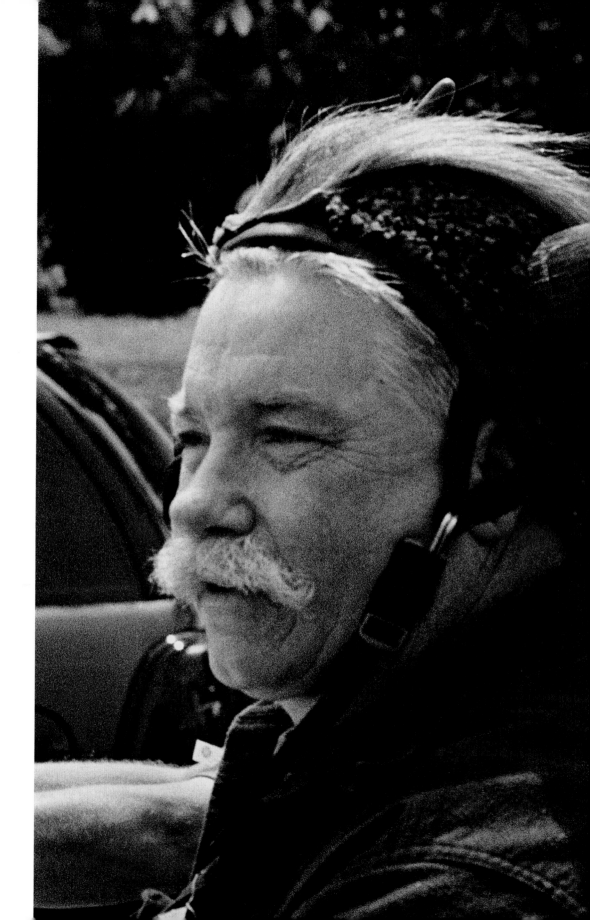

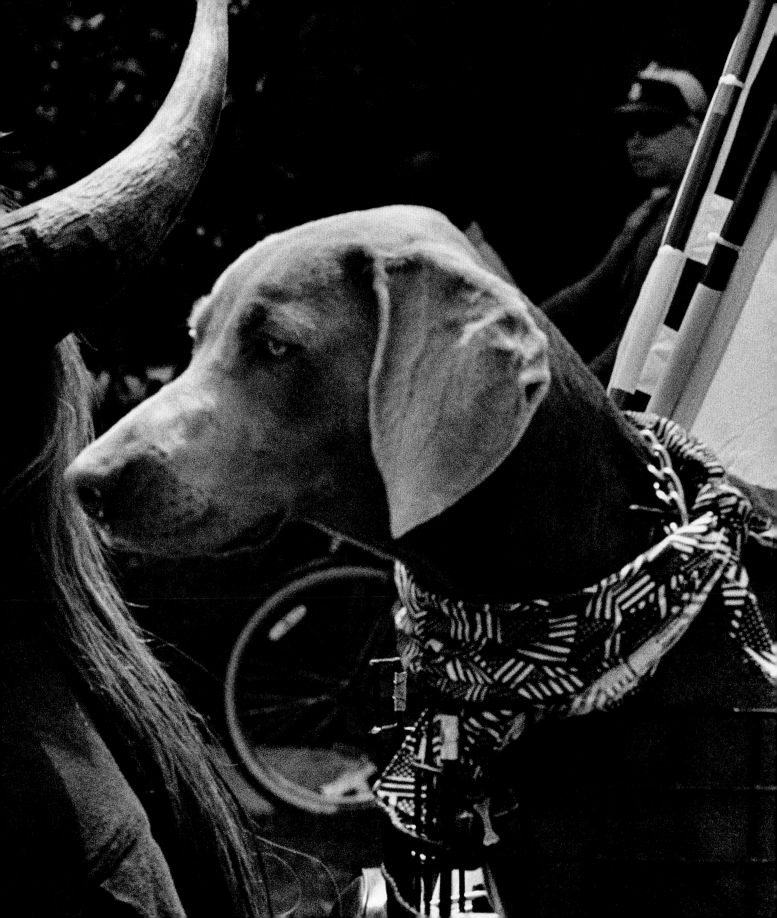

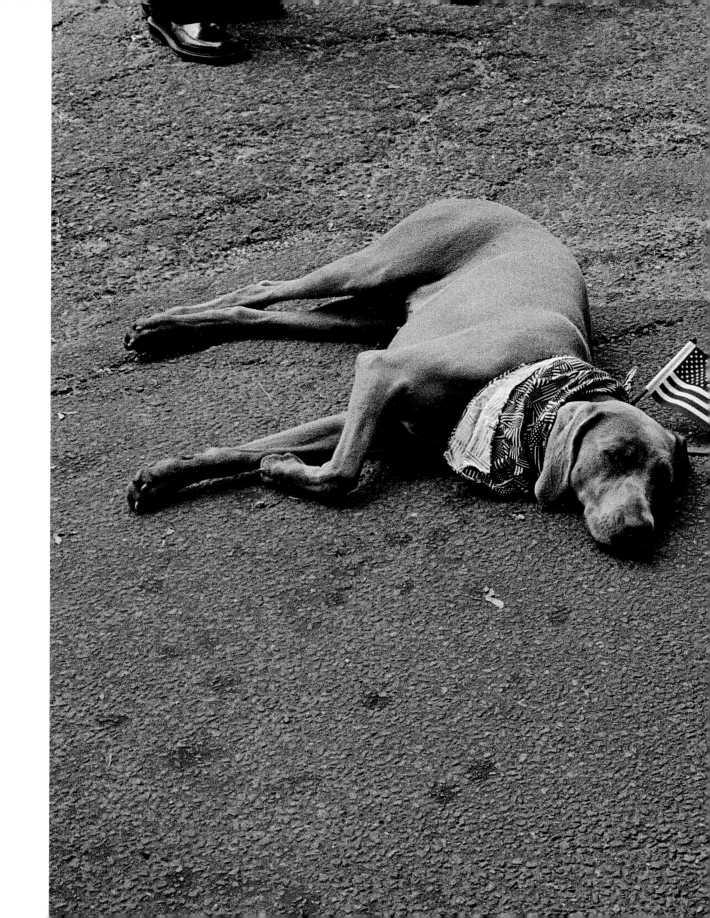

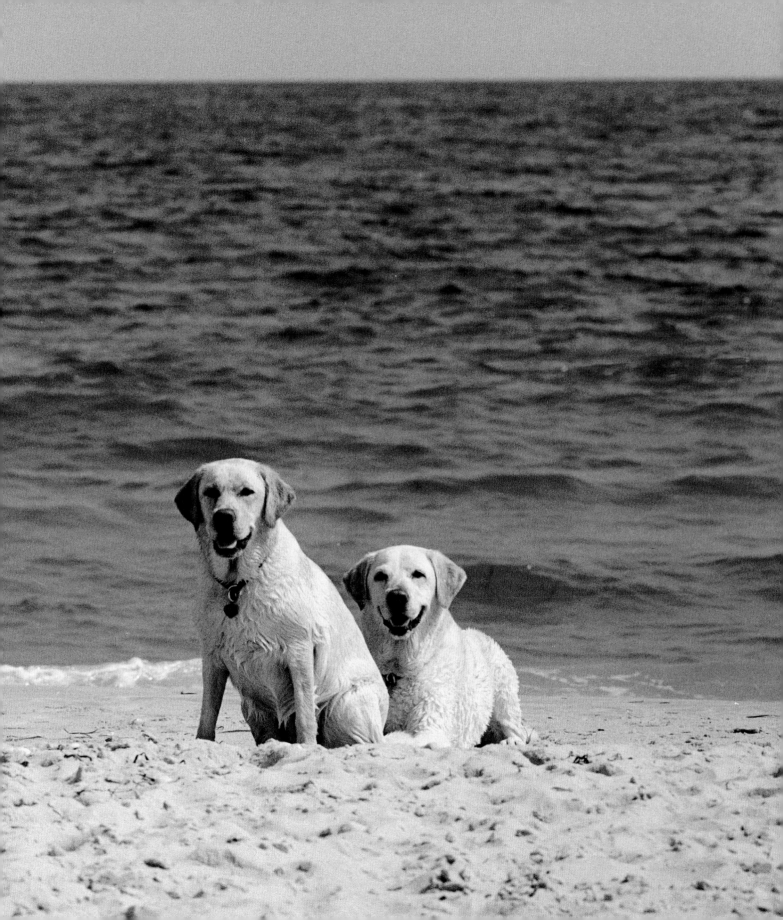

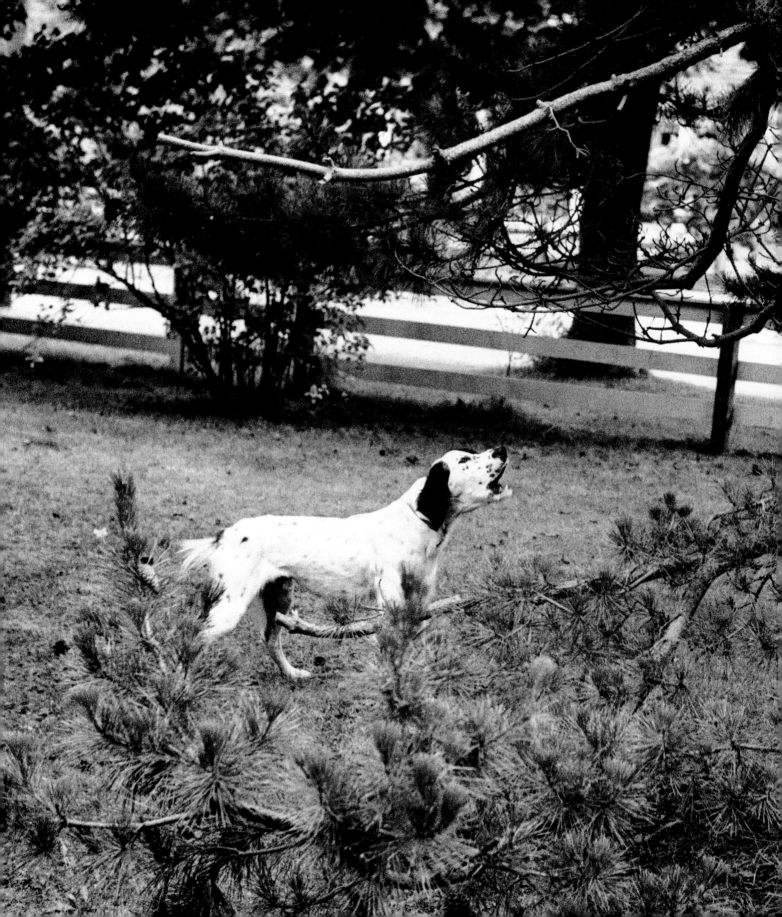

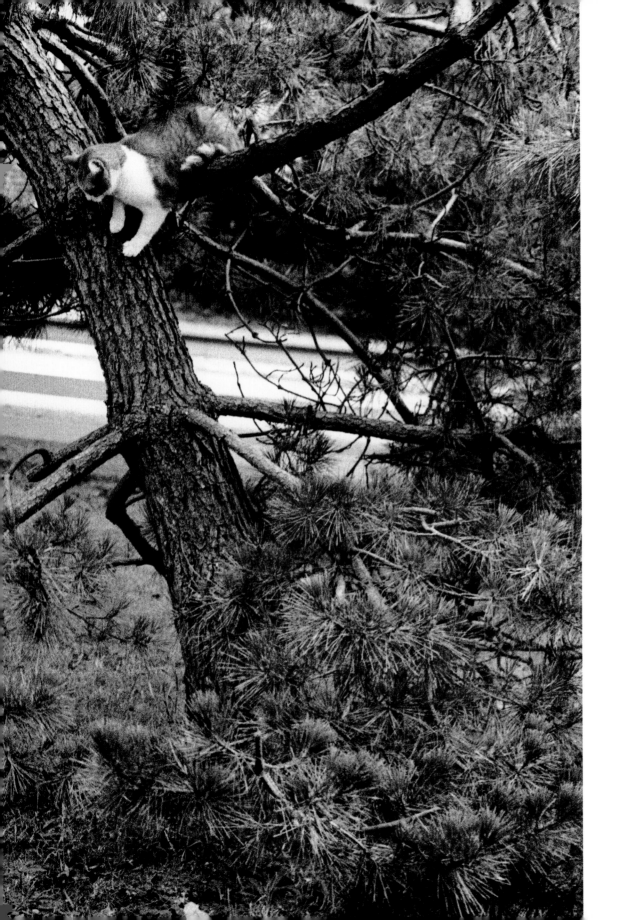

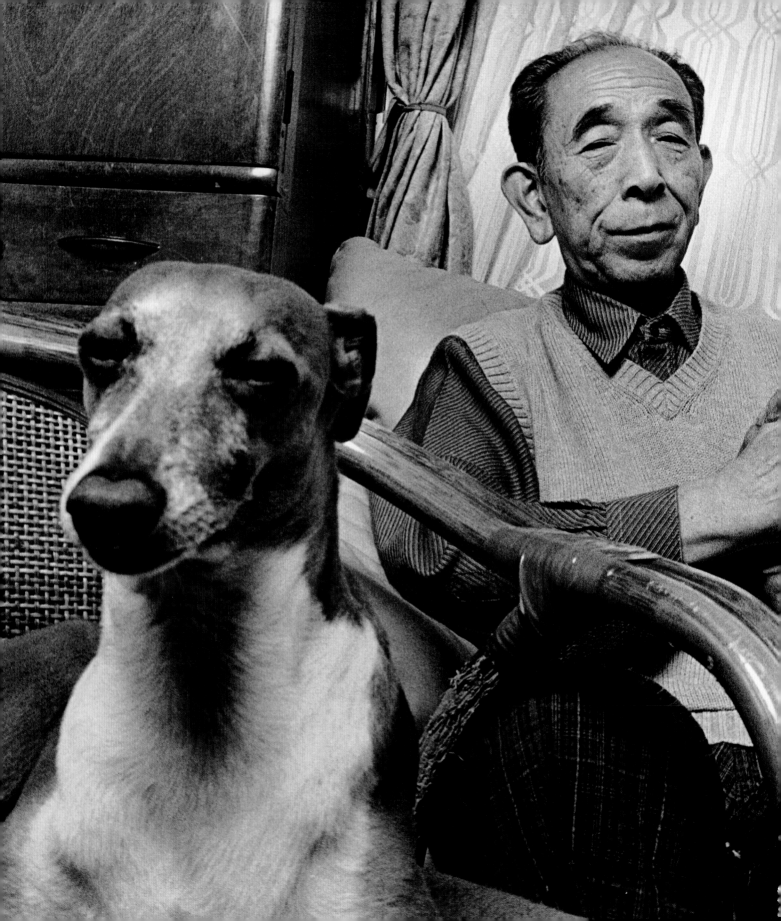

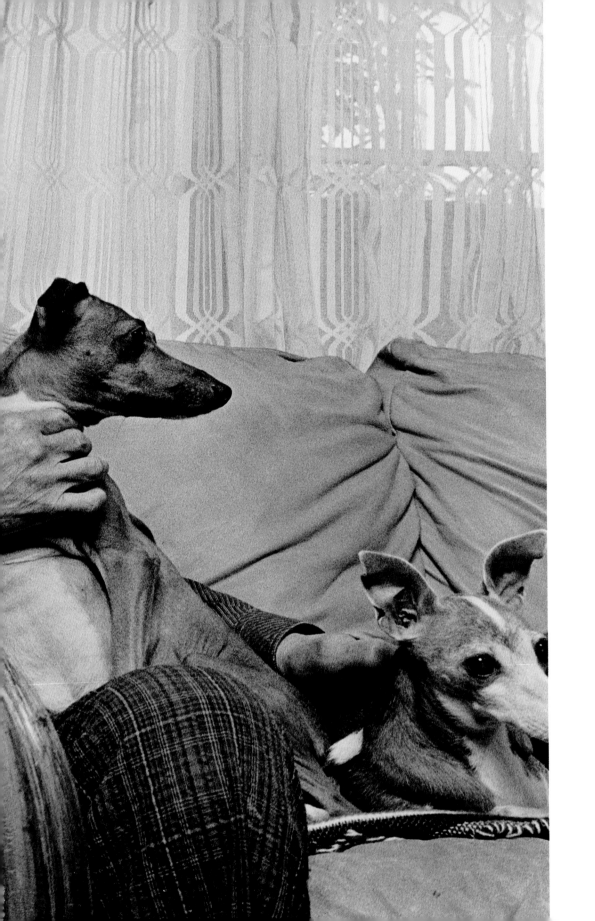

Living with a dog is messy

– like living with an idealist.

— Henry Louis Mencken

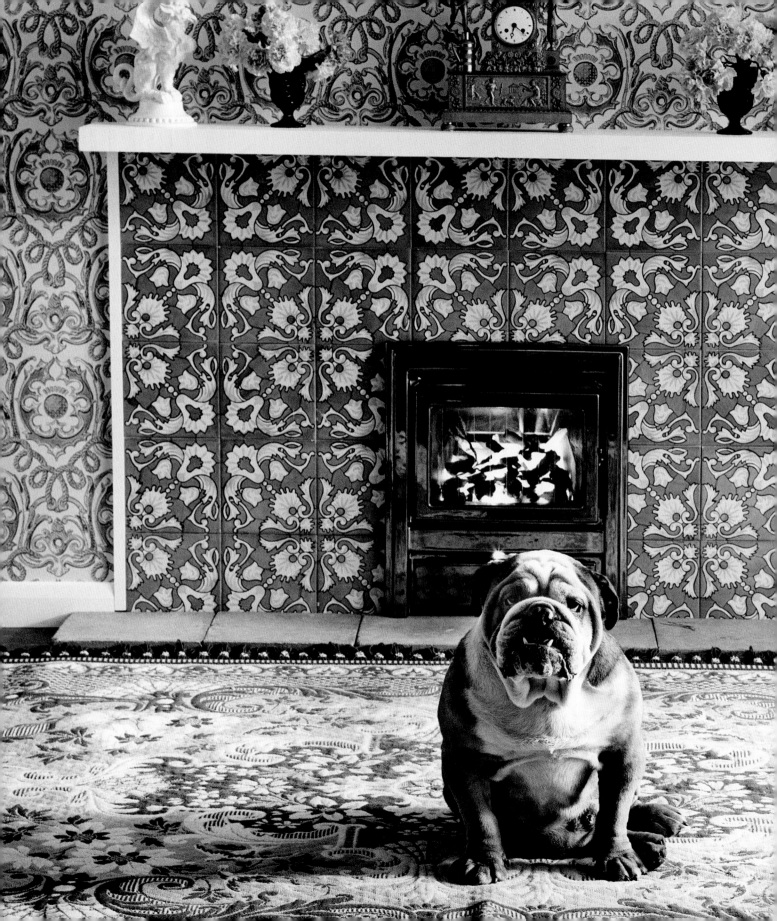

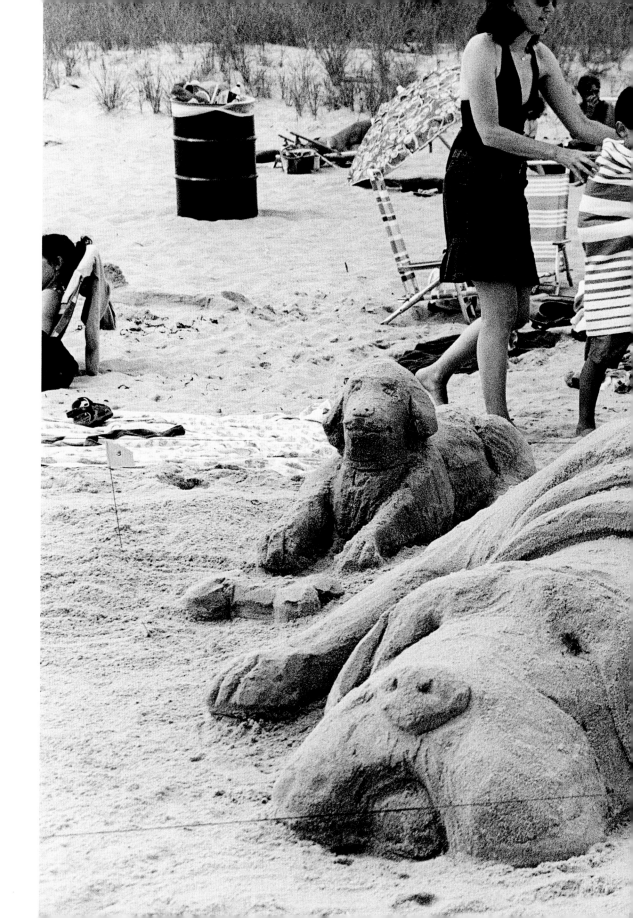

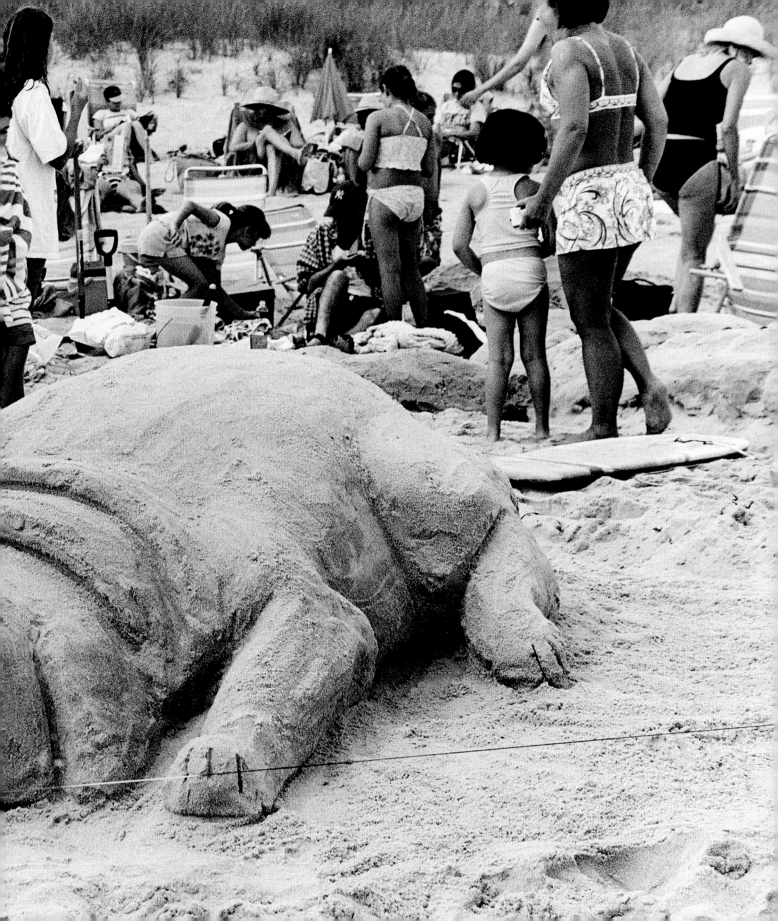

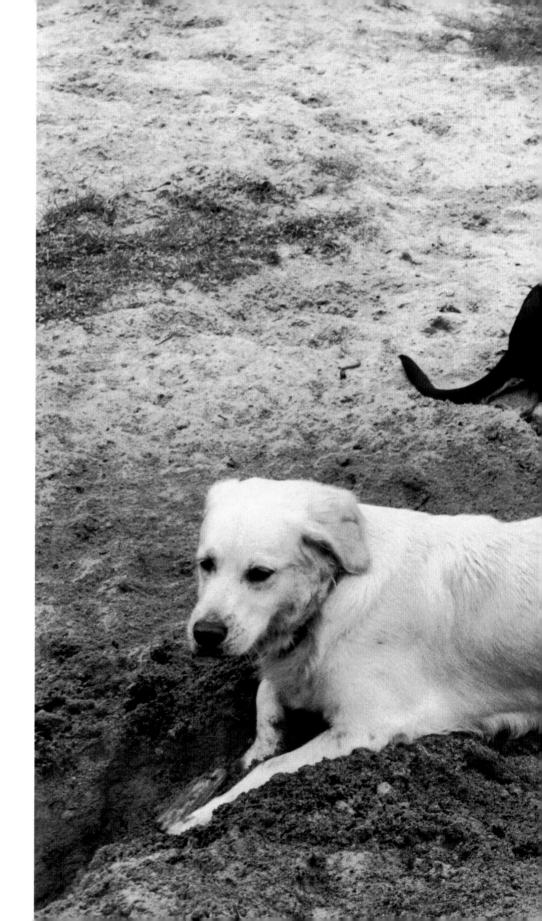

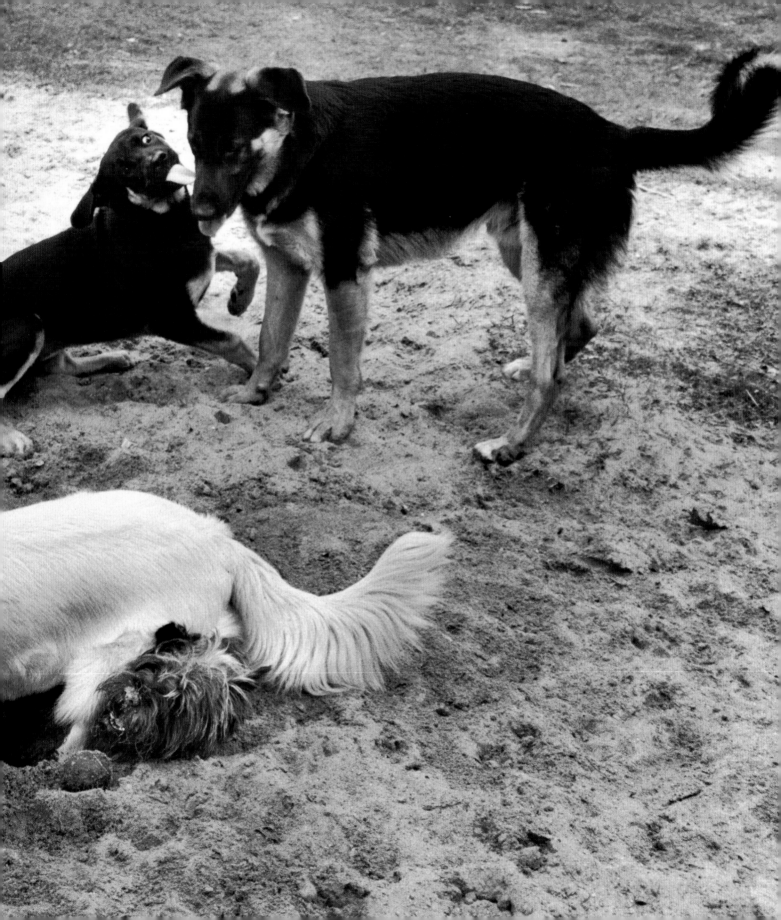

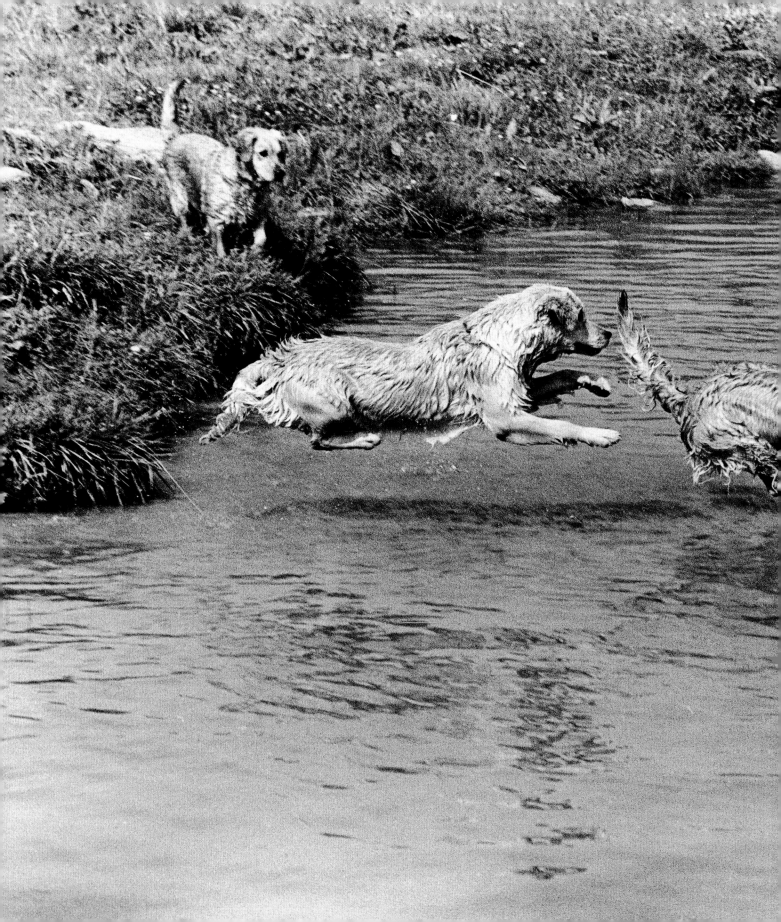

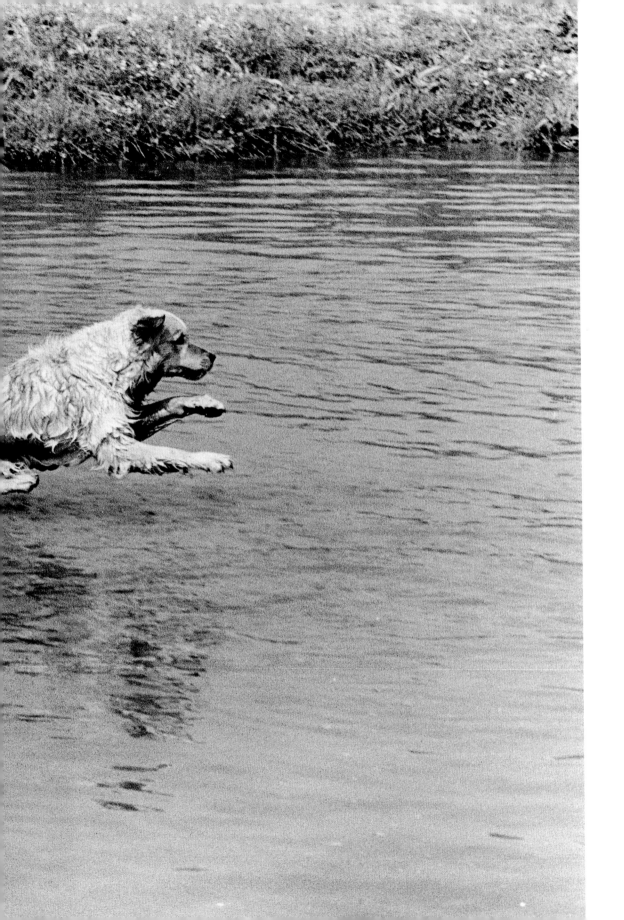

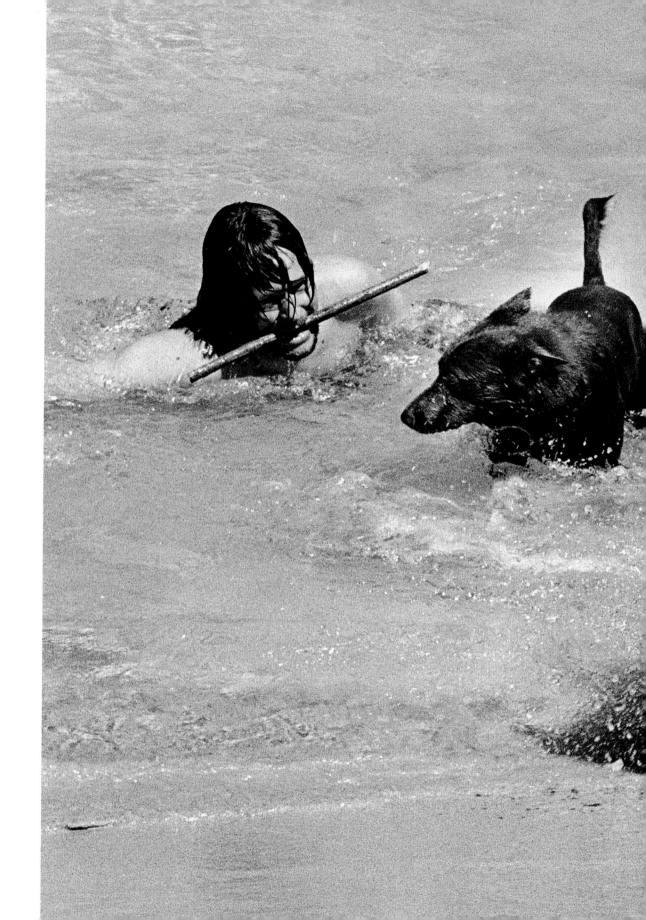

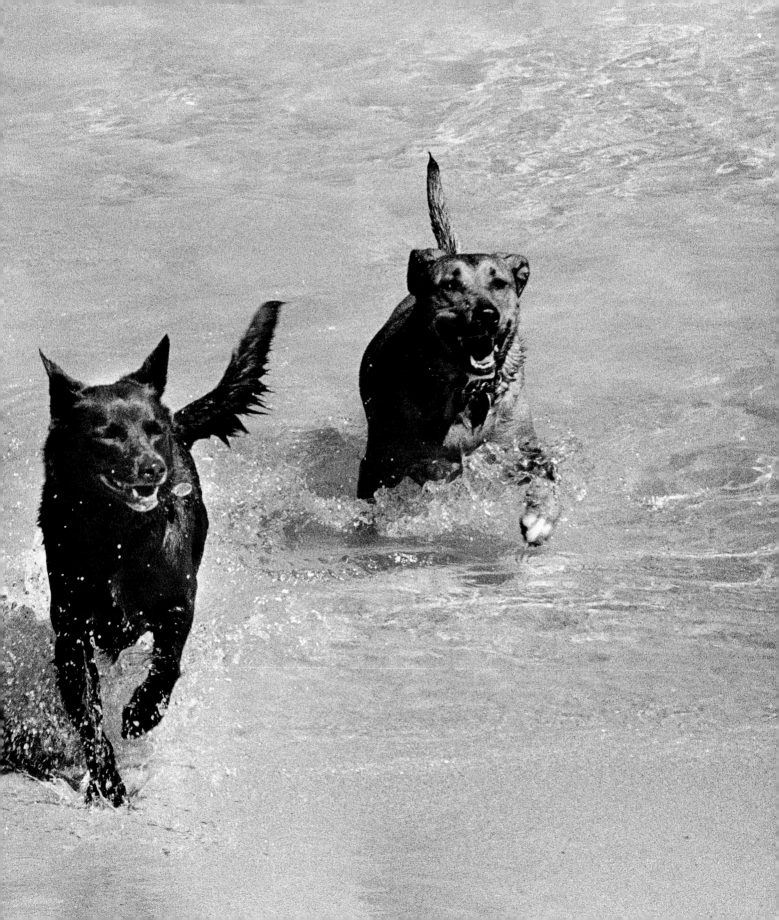

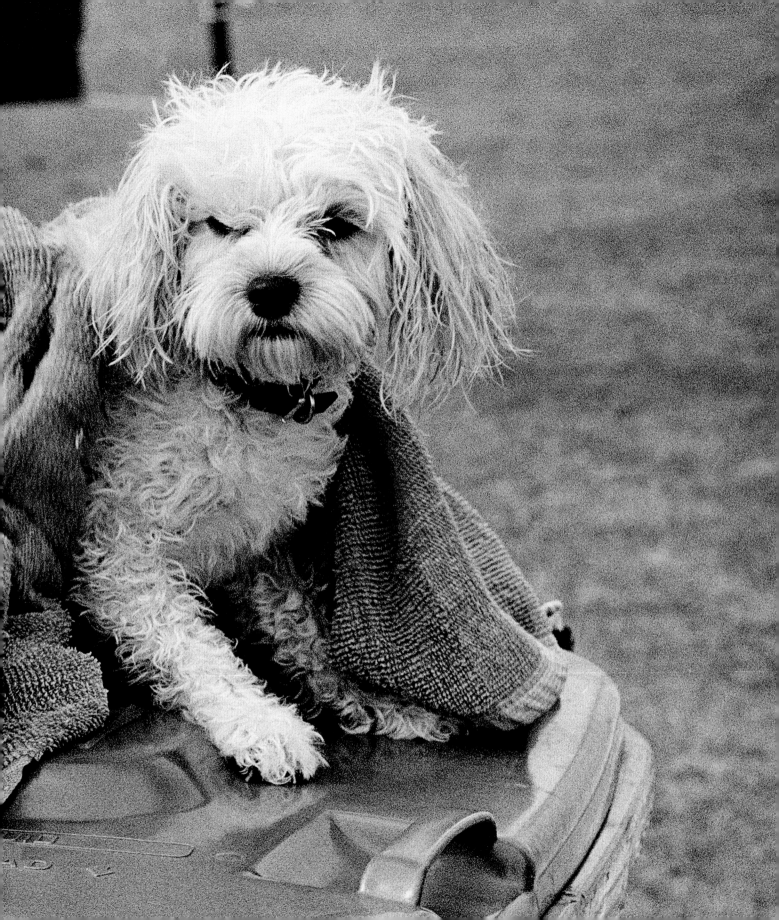

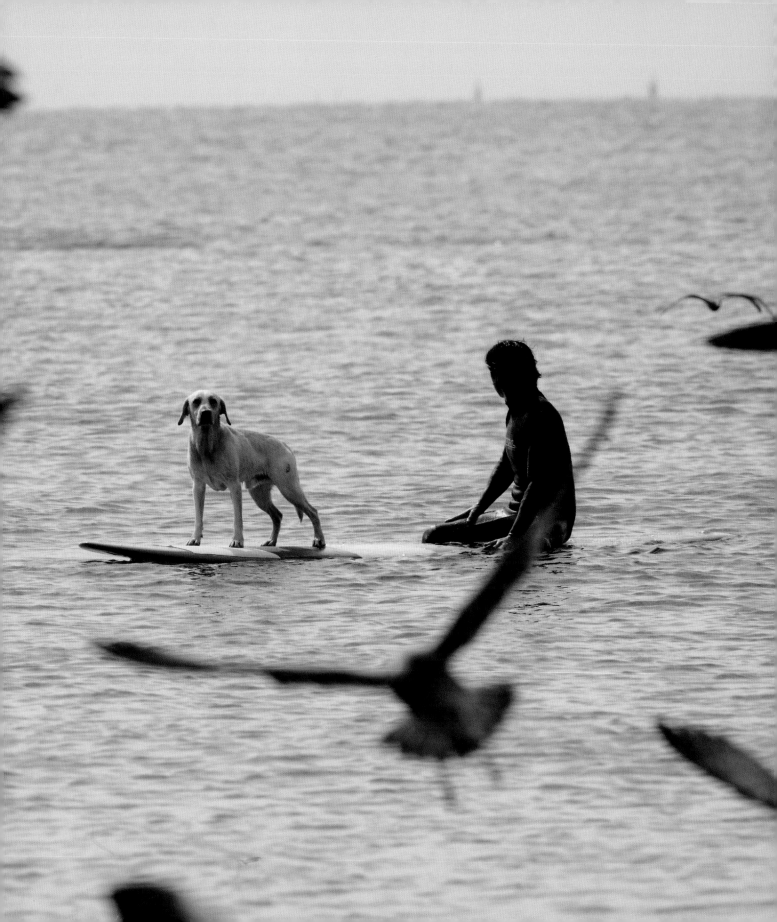

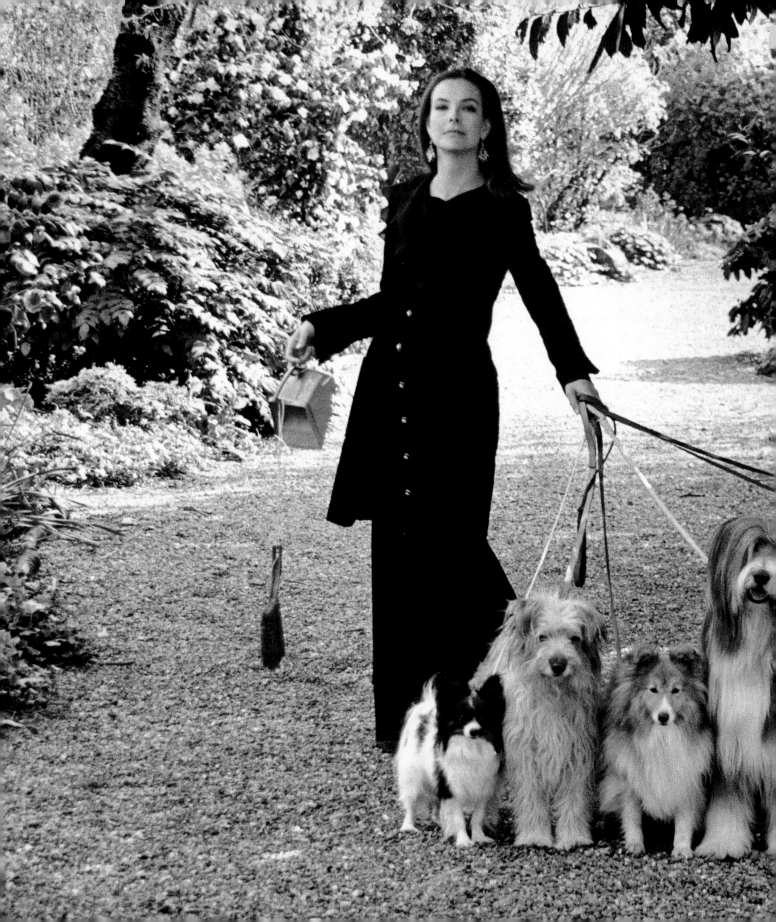

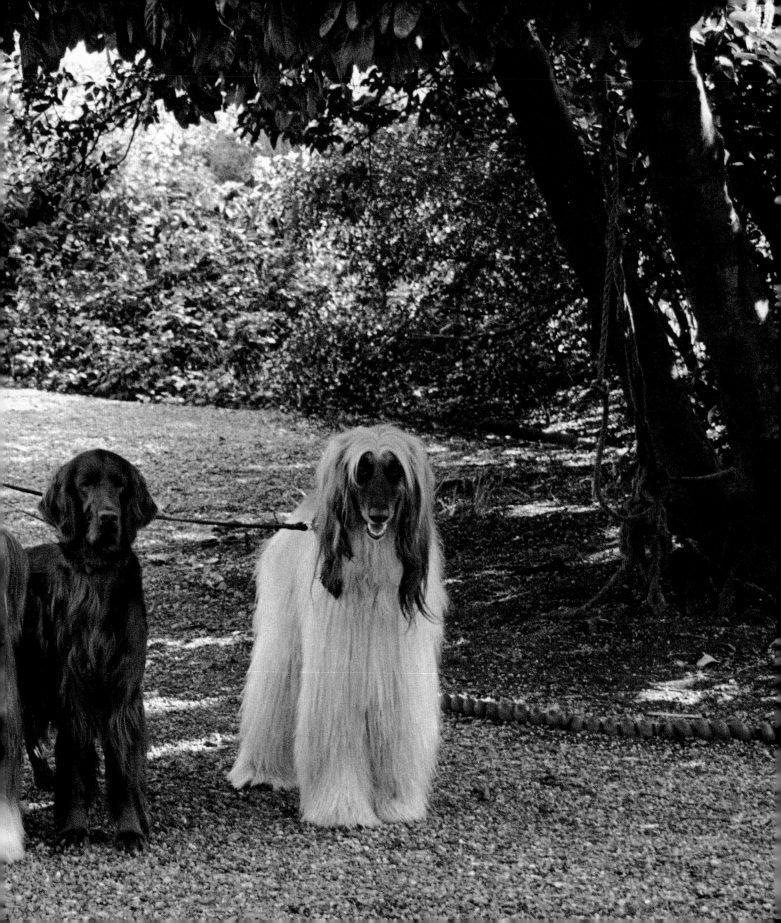

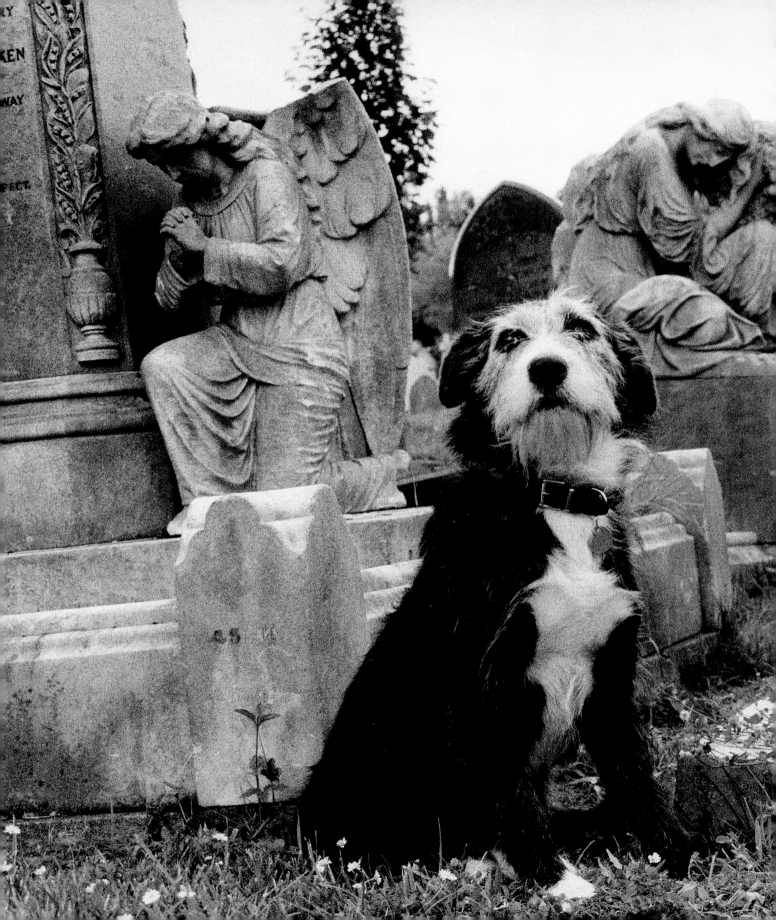

A dog teaches a boy fidelity, perseverance, and to tur

around three times before lying down – very important traits in times like these. — Robert Benchley

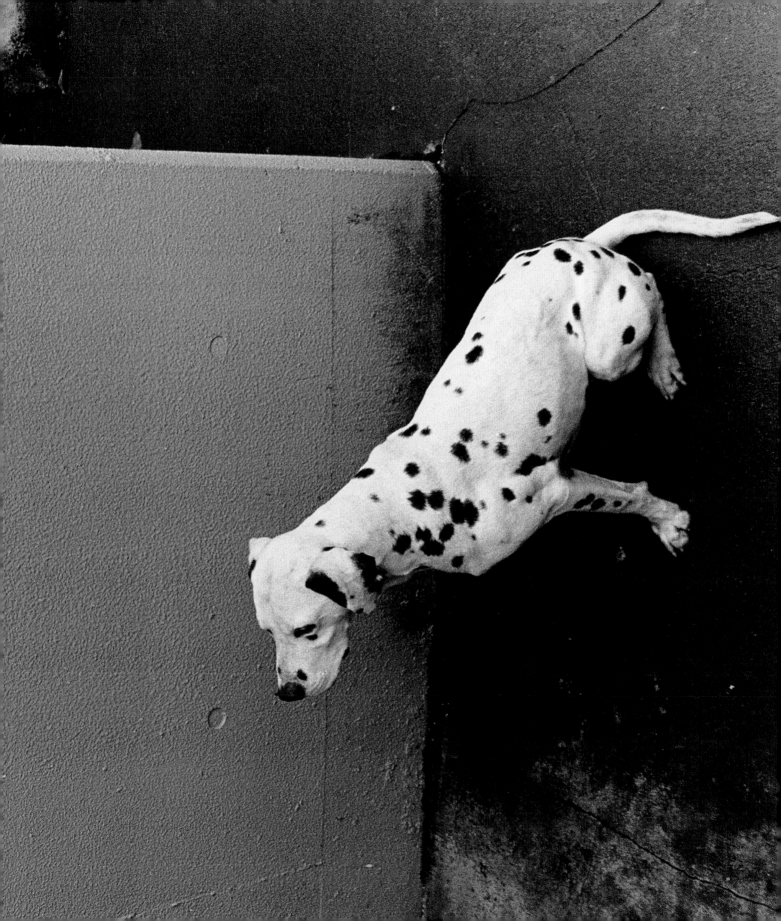

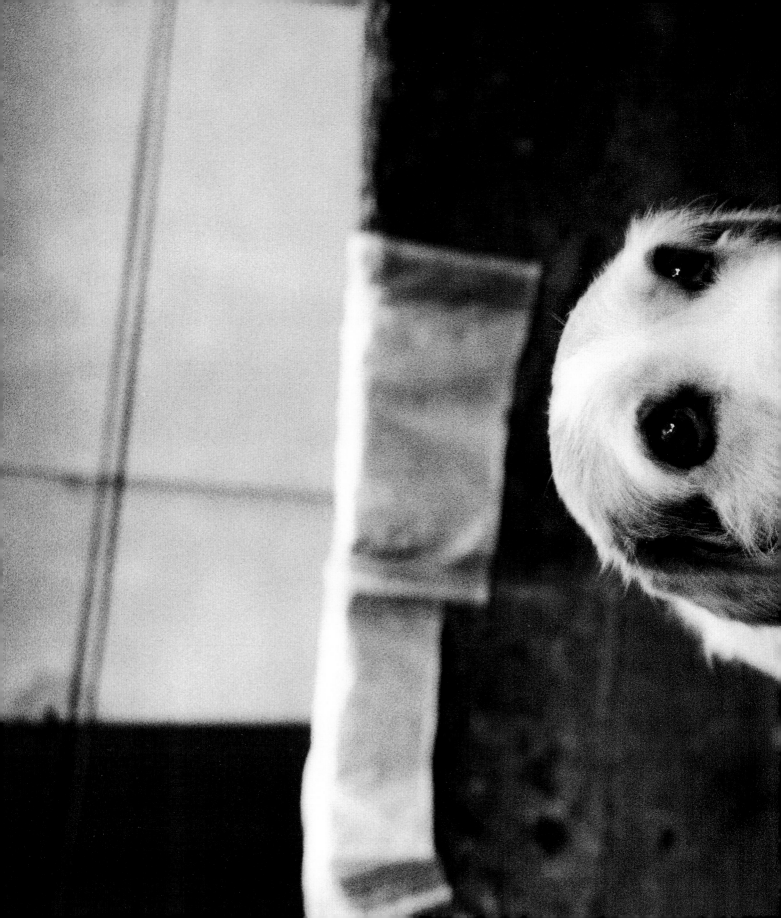

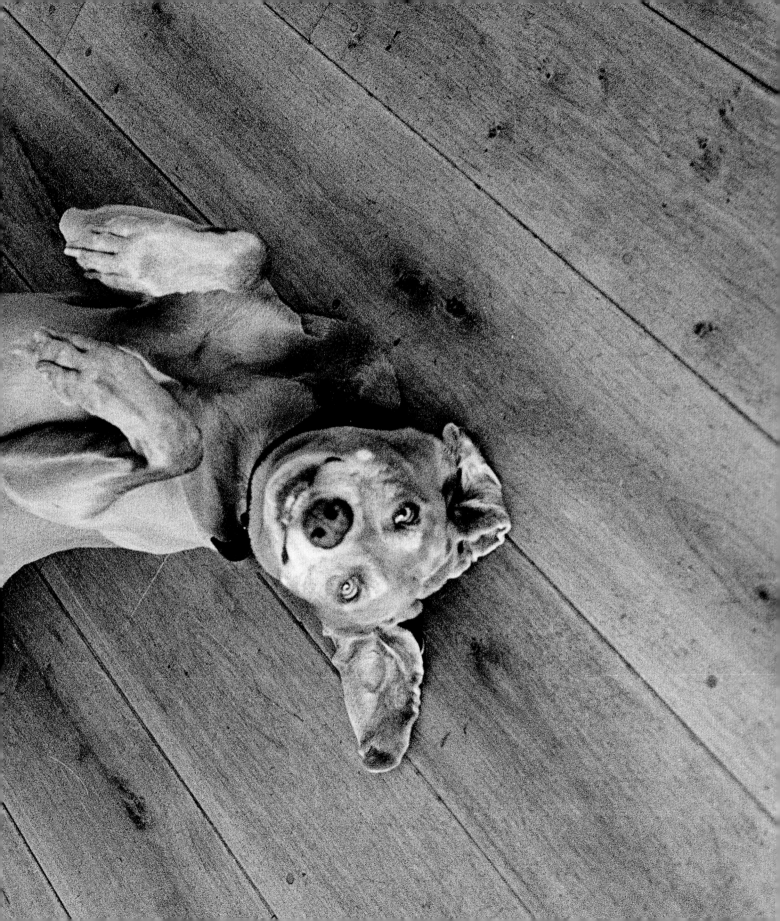

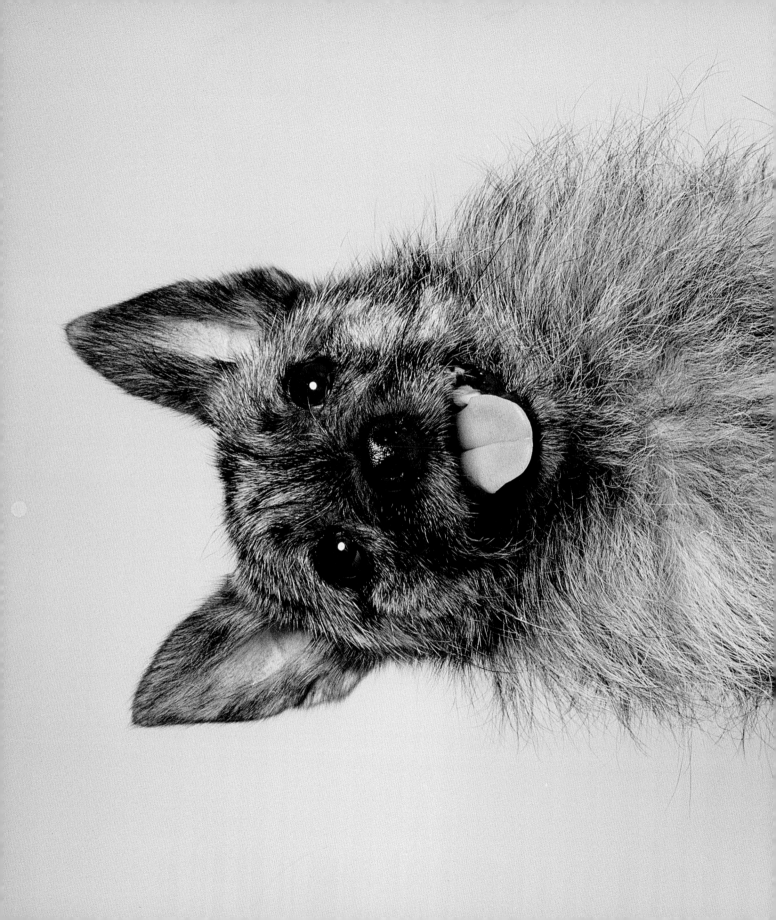

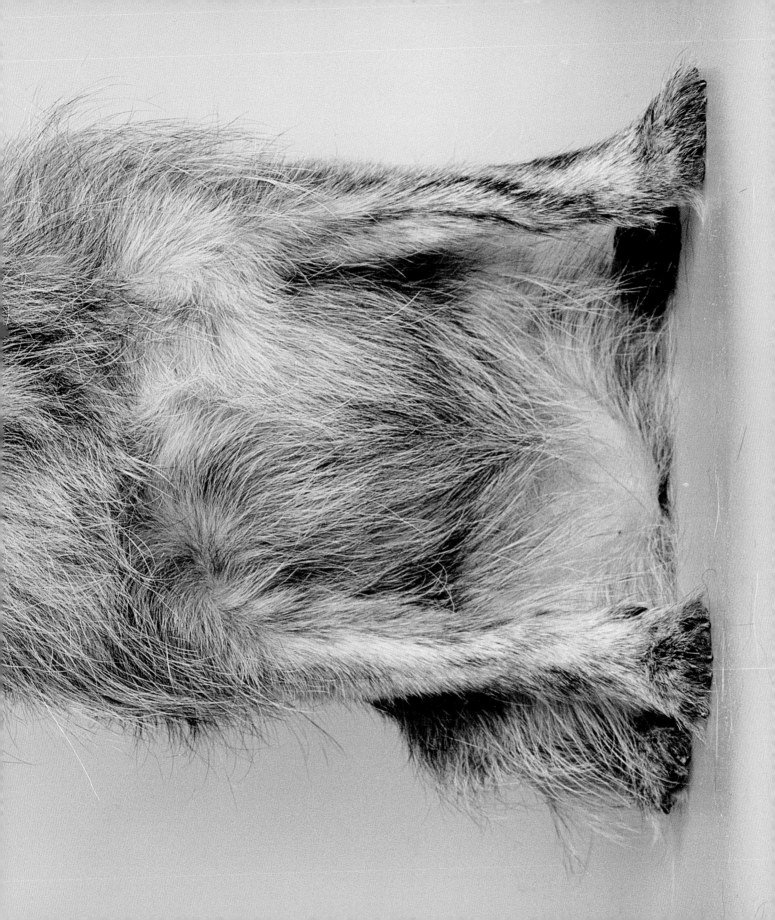

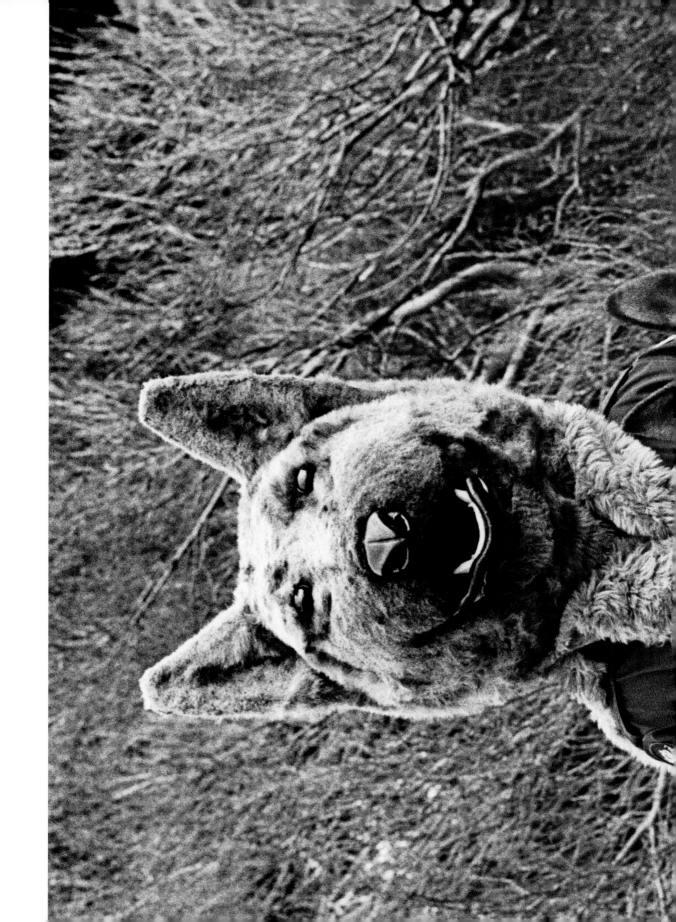

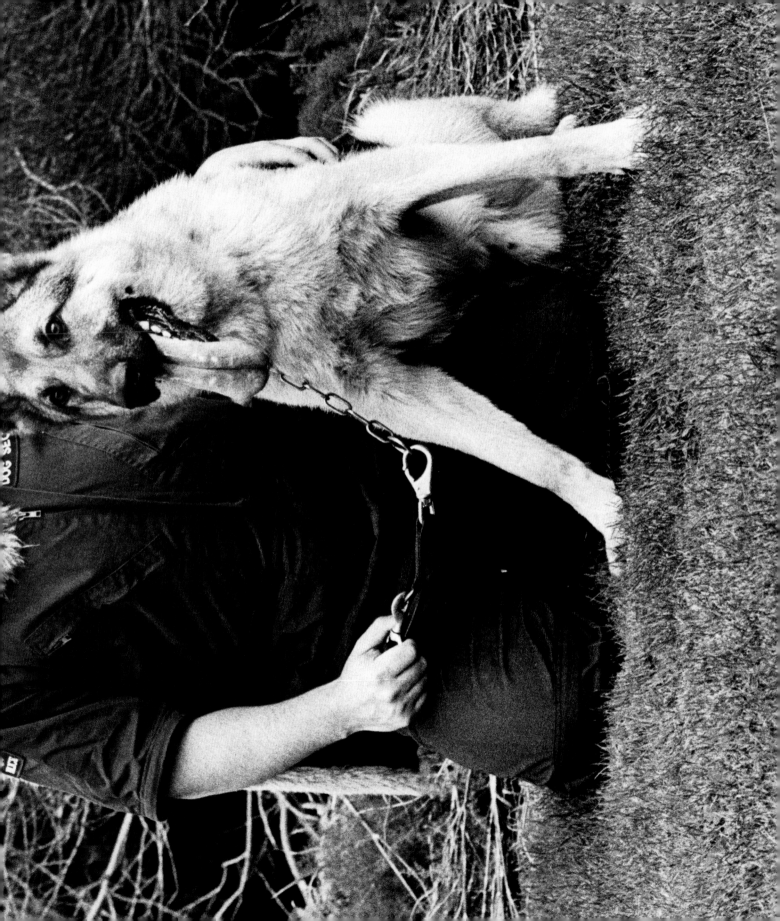

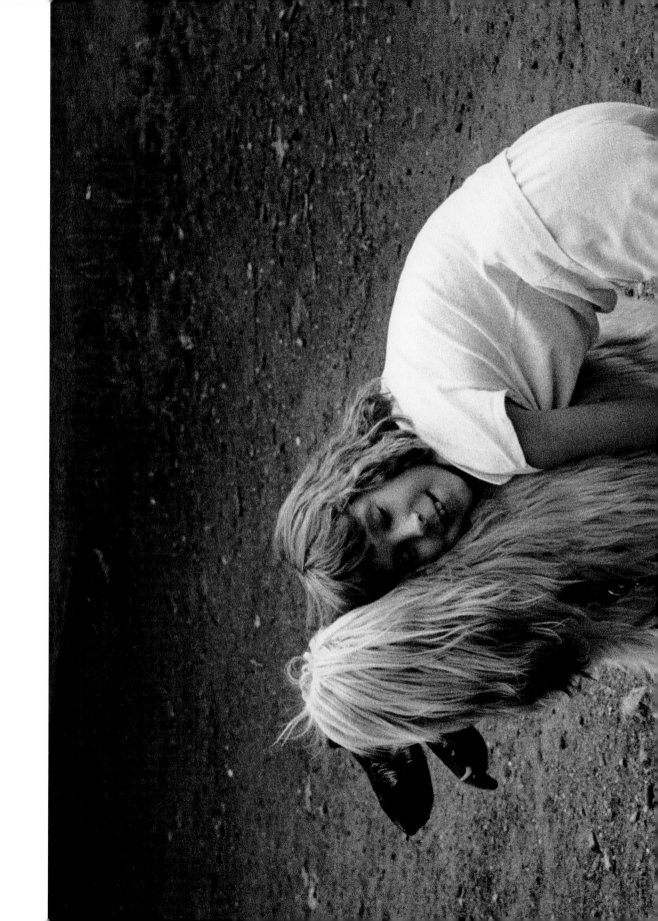

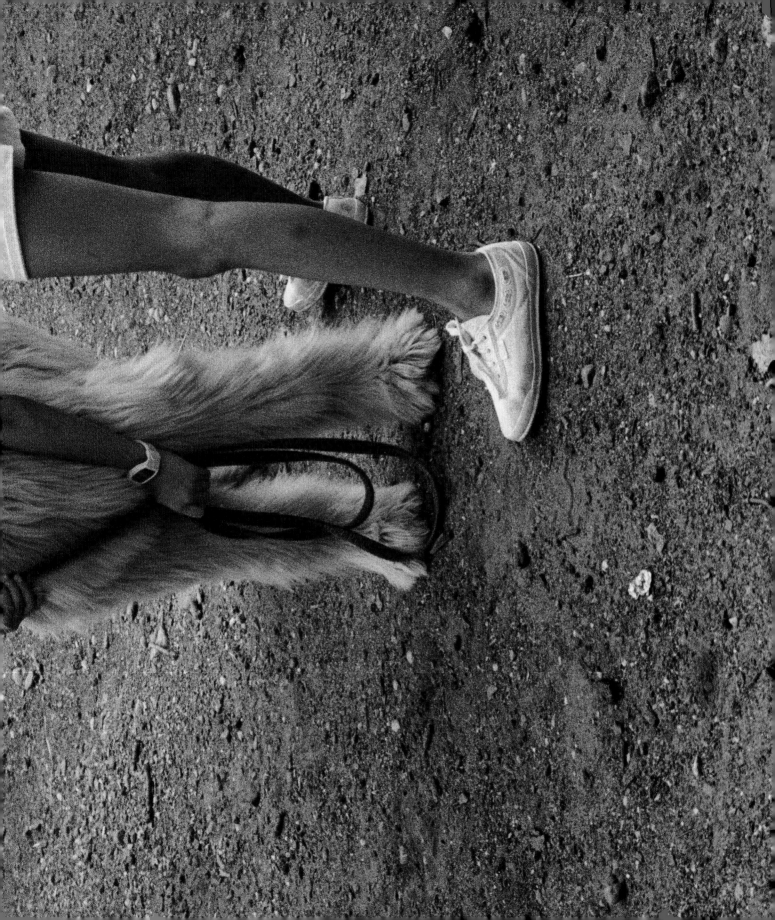

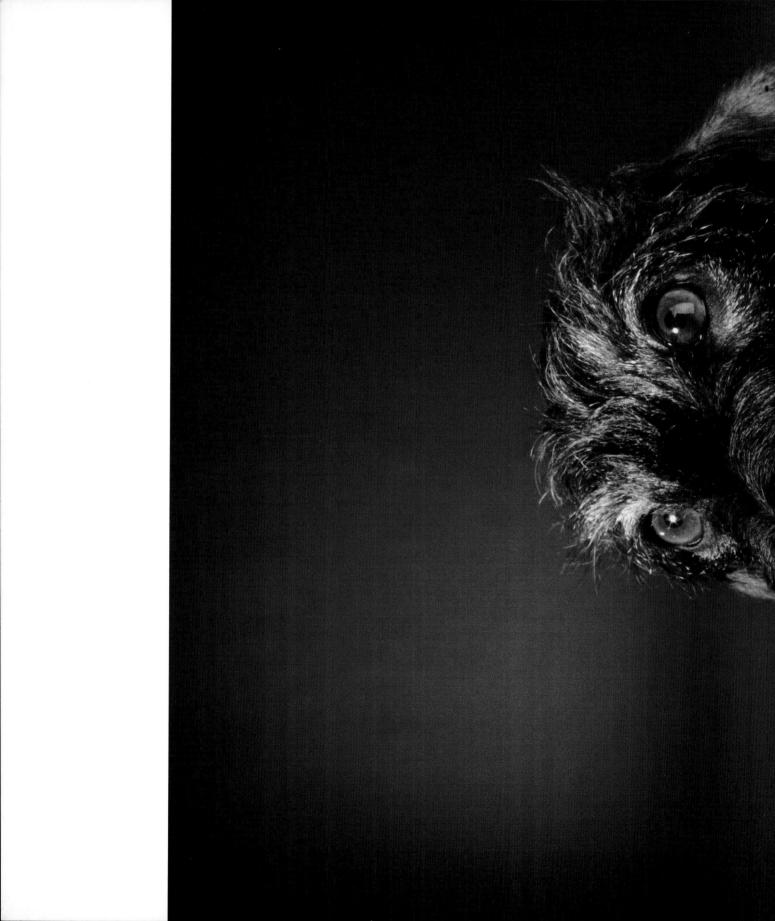

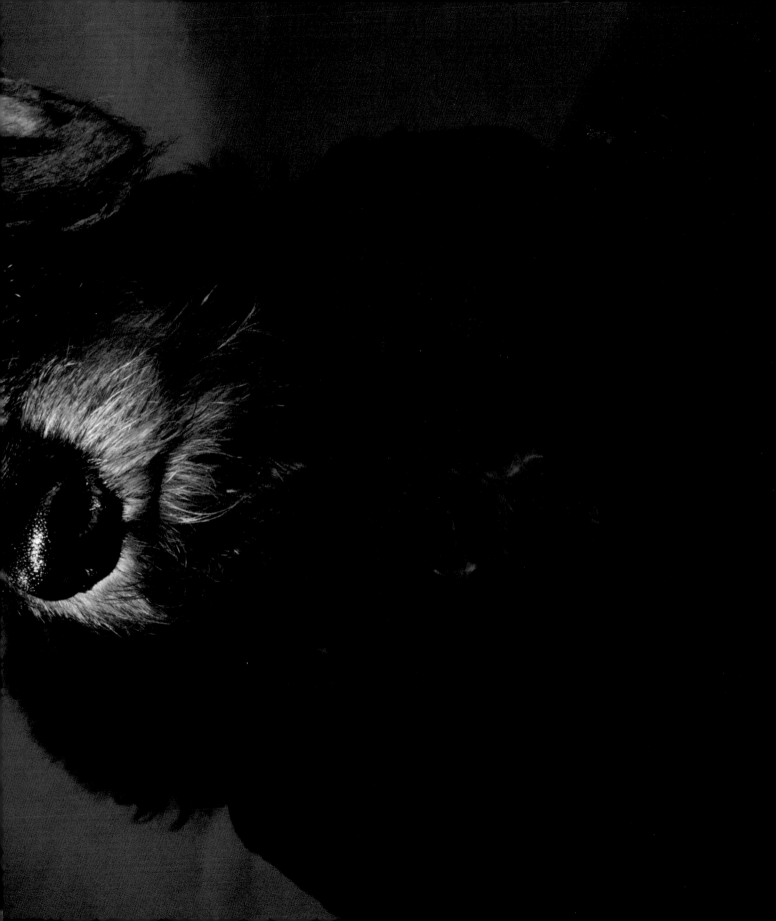

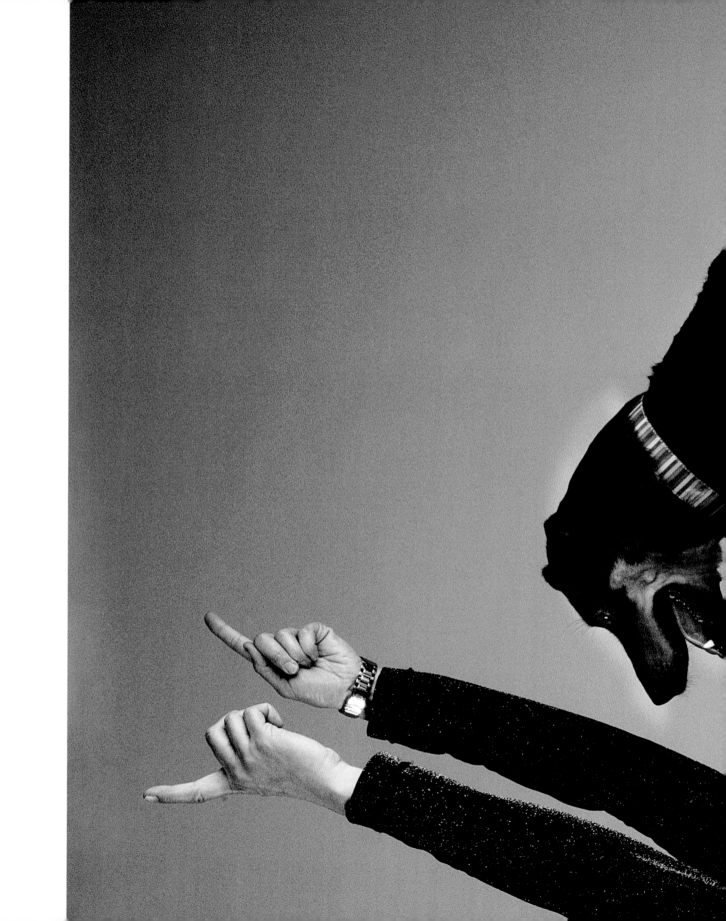

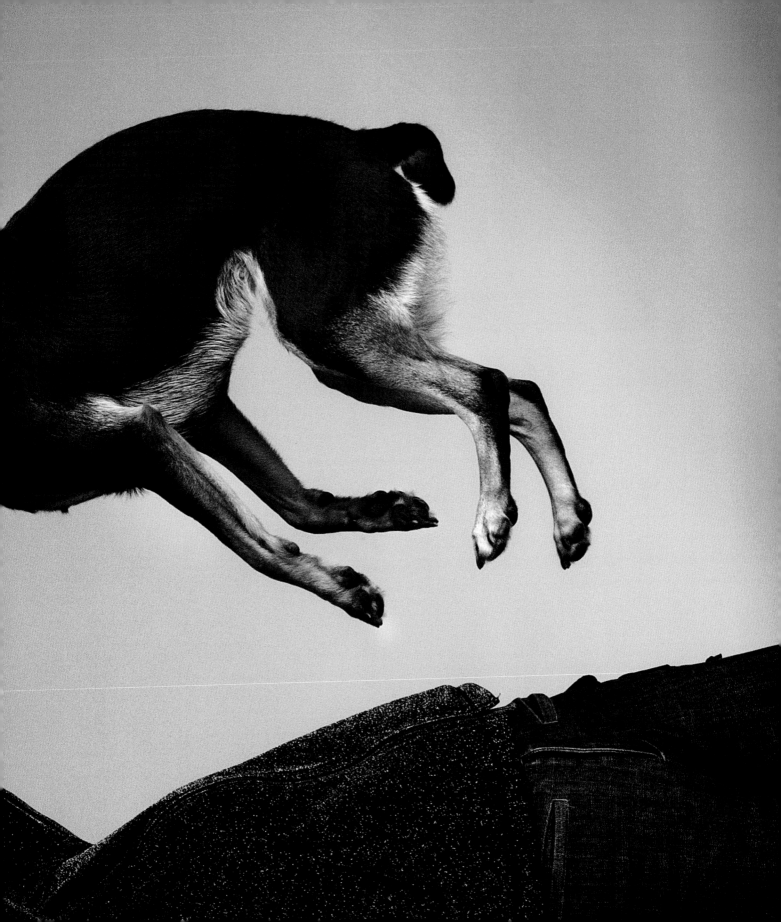

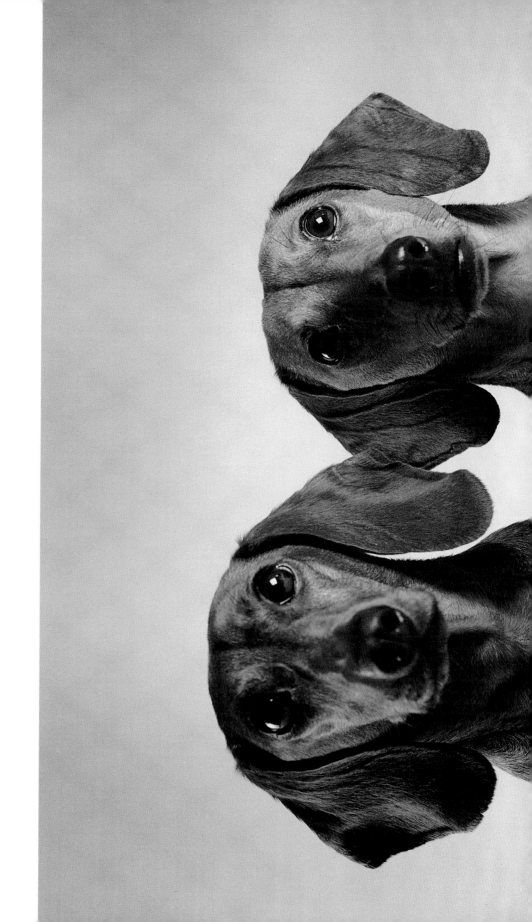

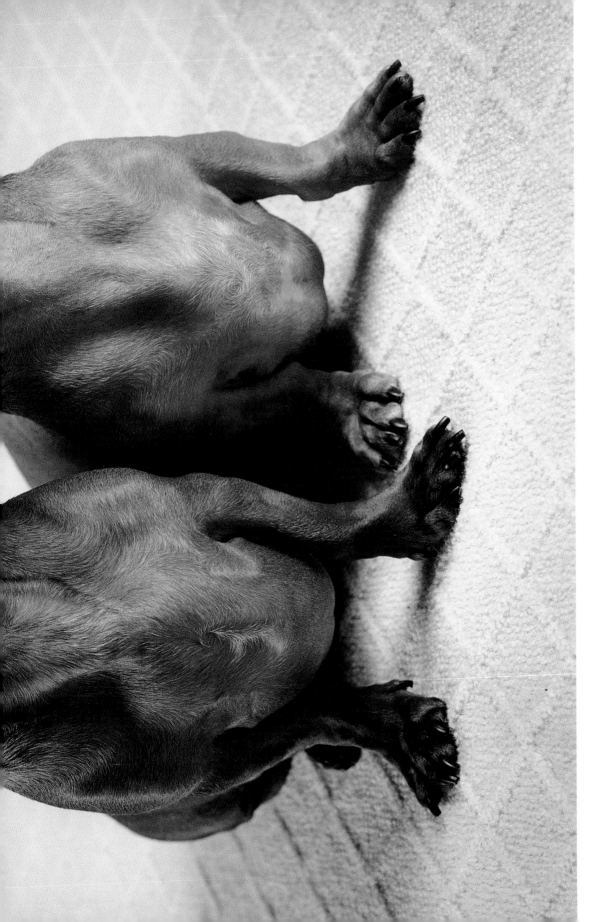

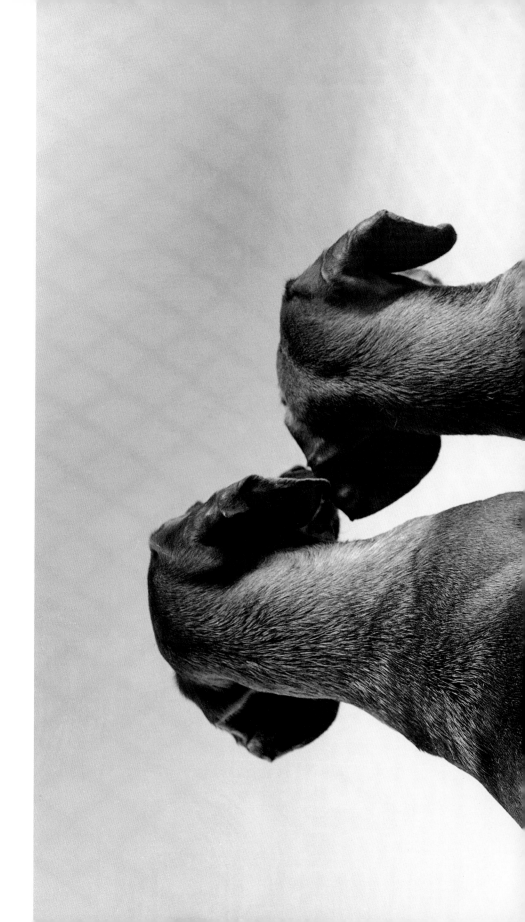

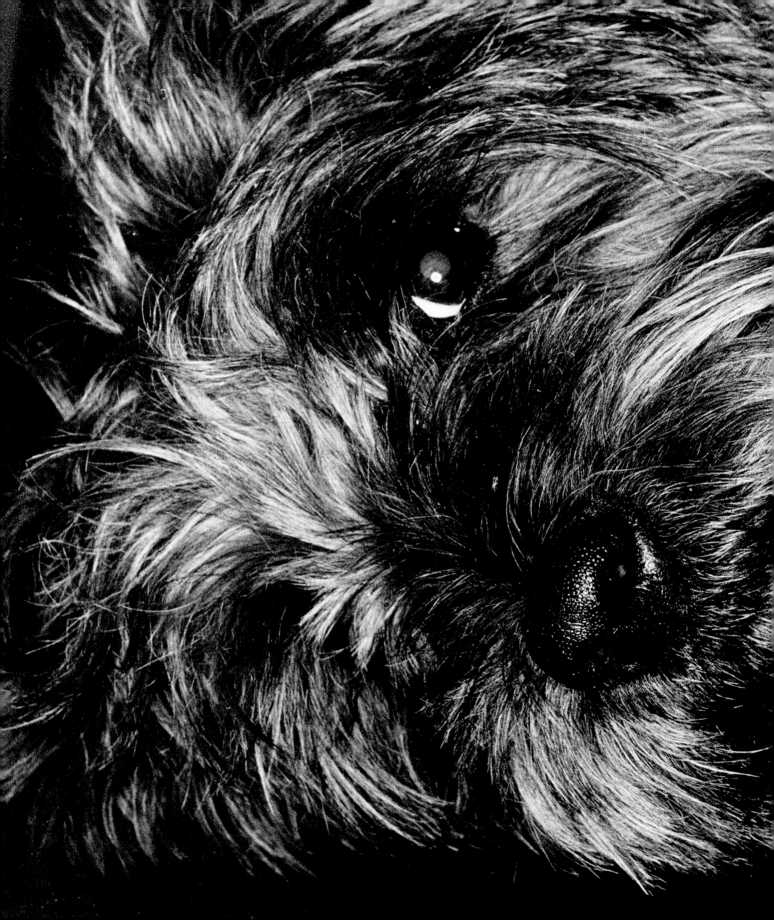

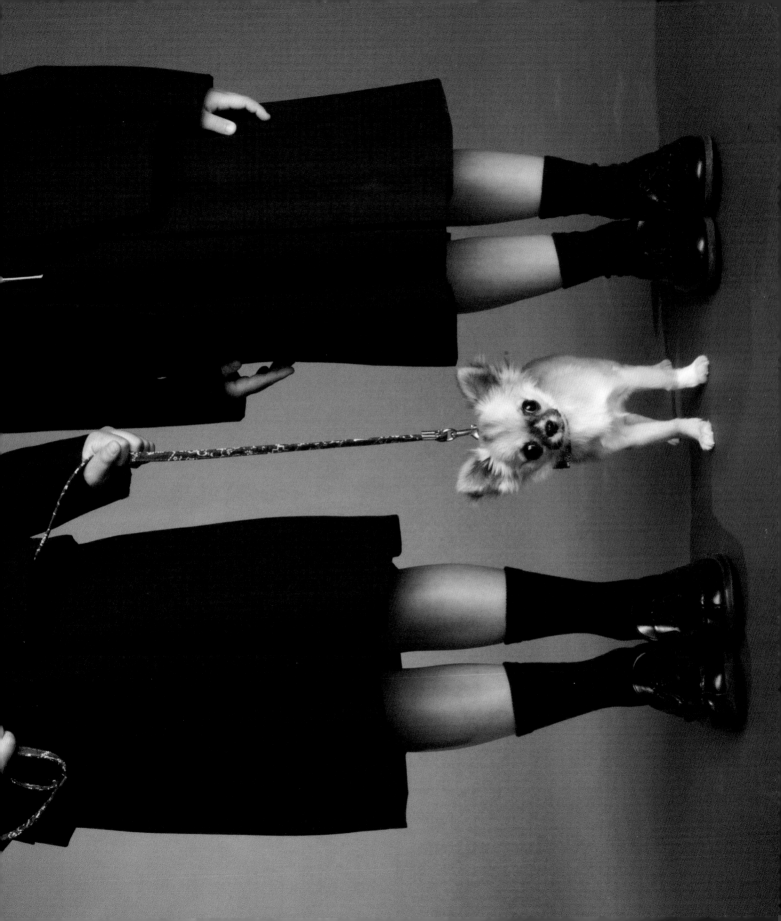

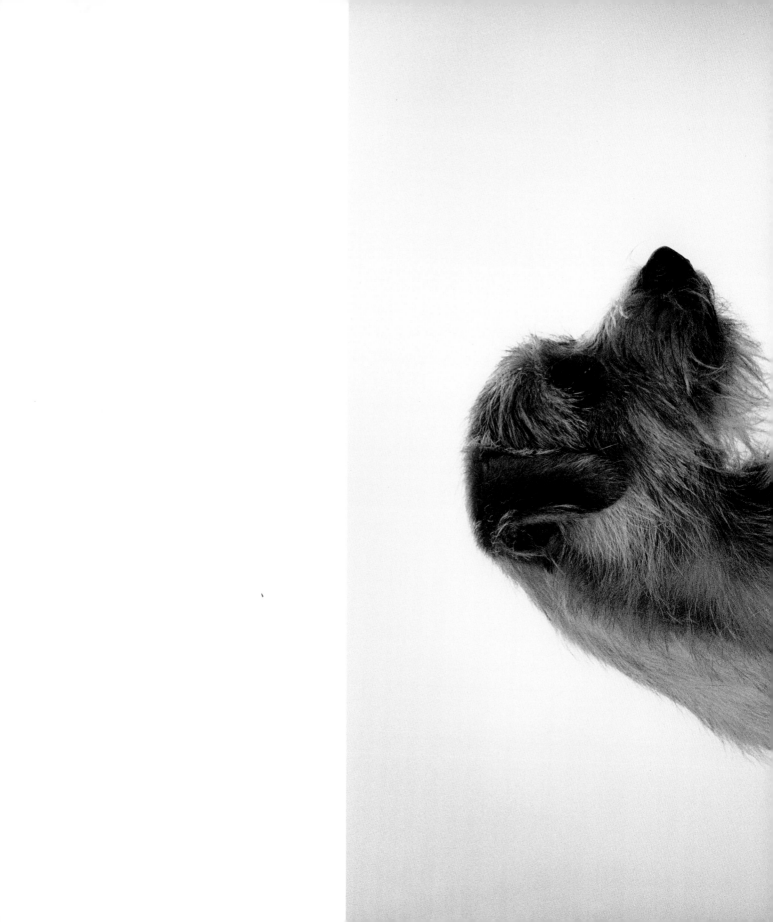

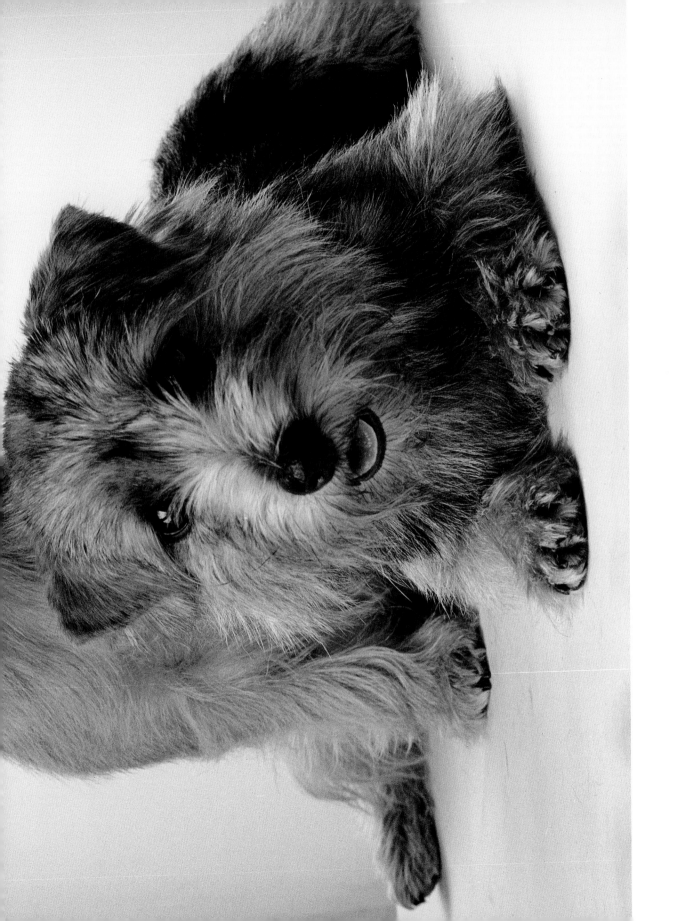

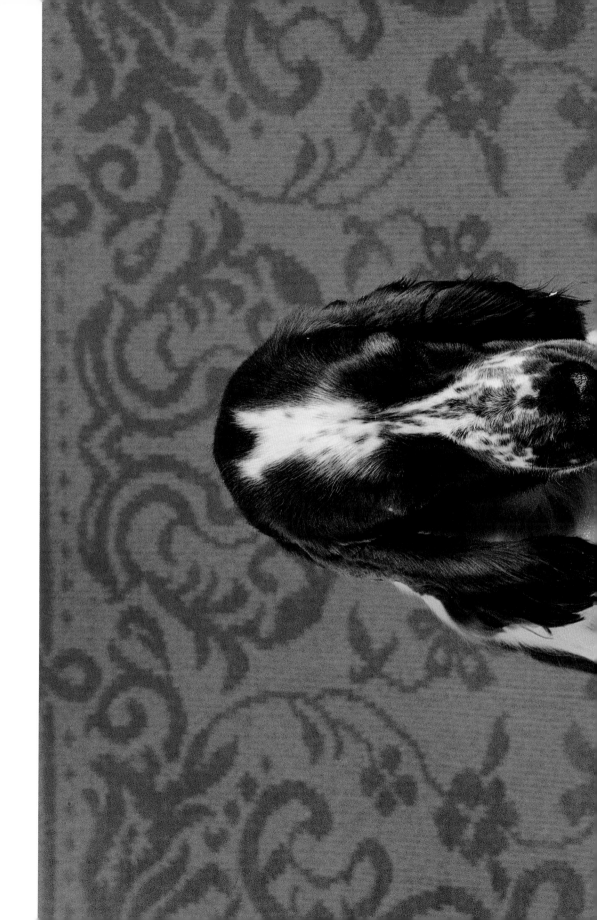

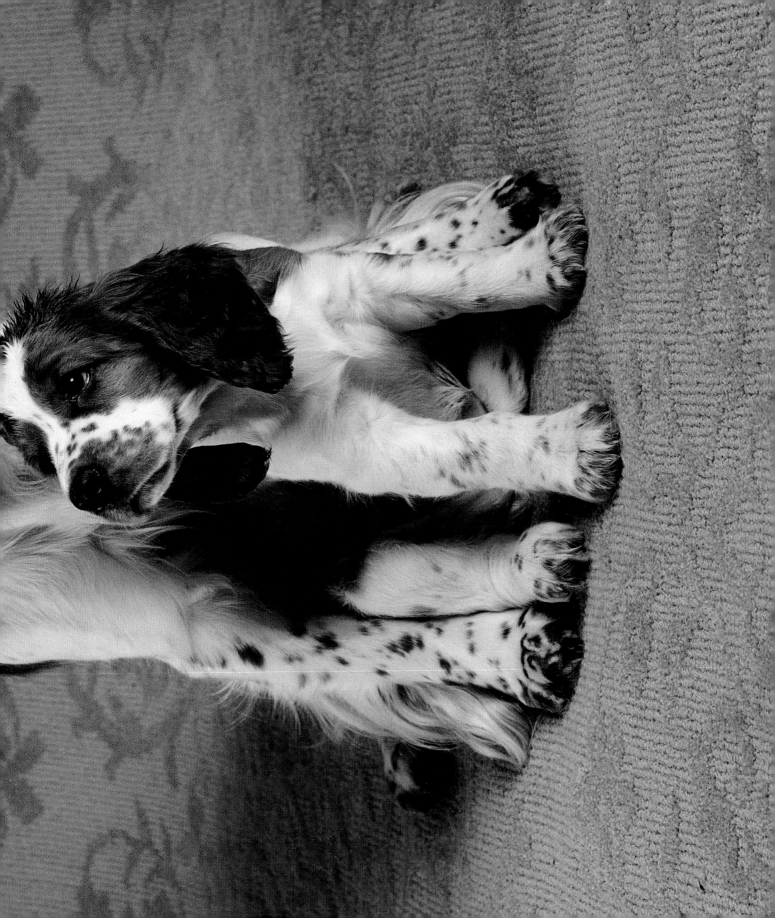

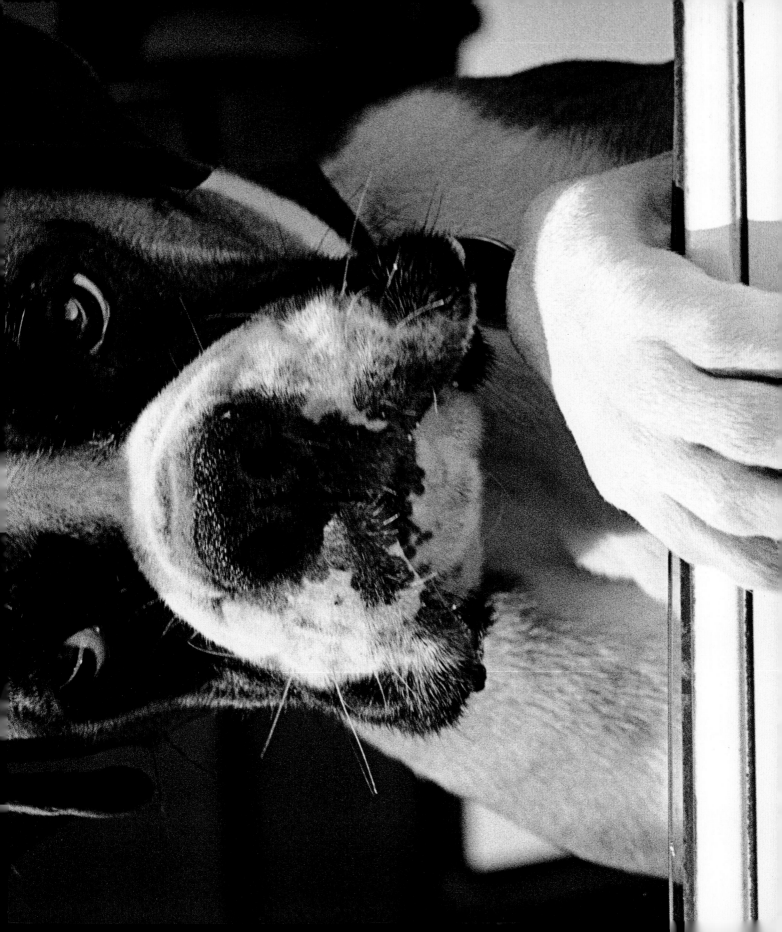

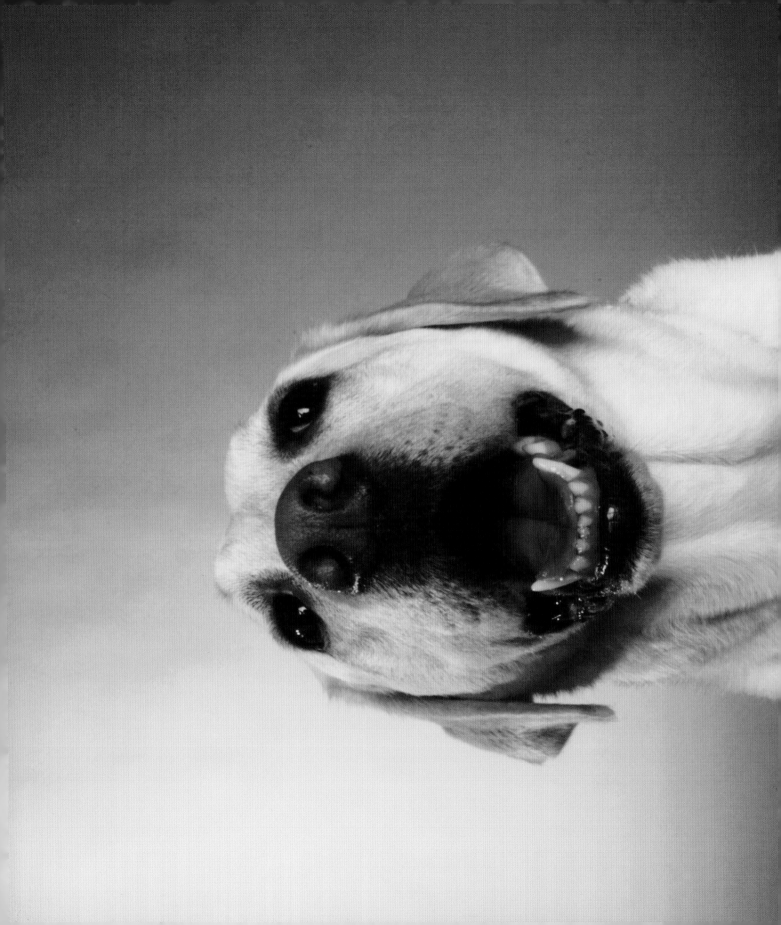

My dog can bark like a congressman, fetch like an aide, beg like a press secretary, and play dead like a receptioni

when the phone rings. — Gerald B.H. Solomon, quoted in *The New York Times*

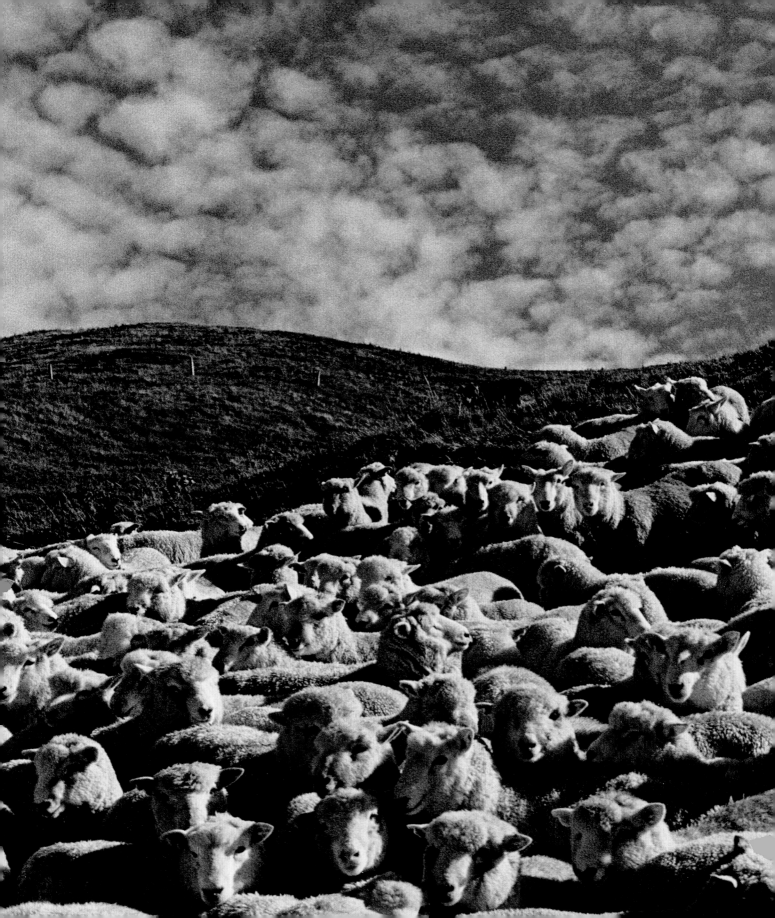

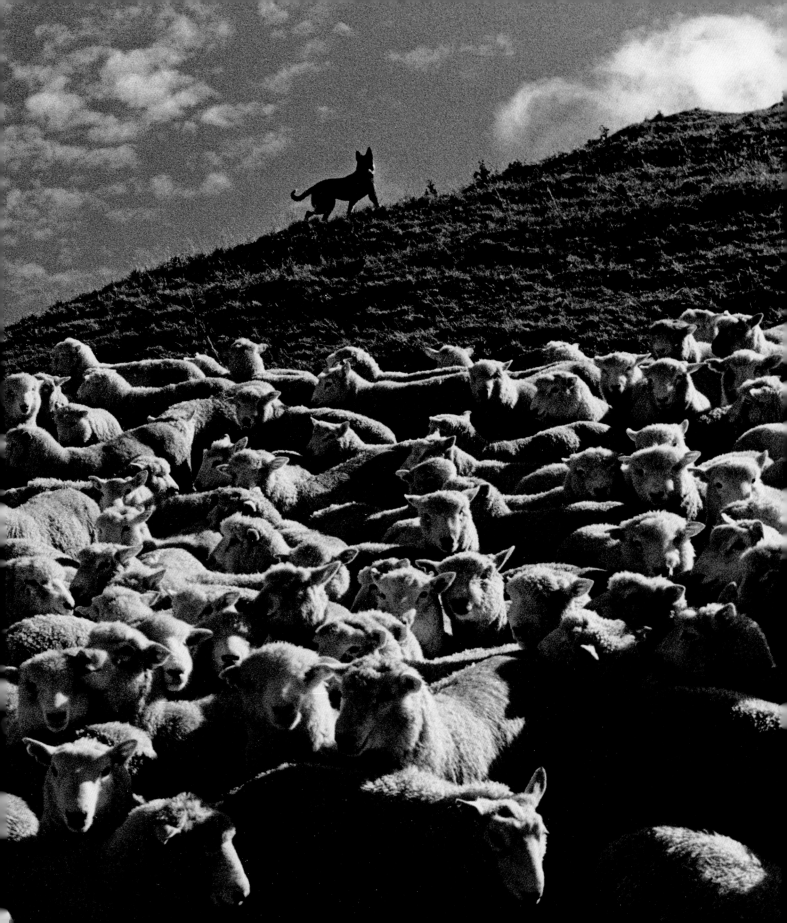

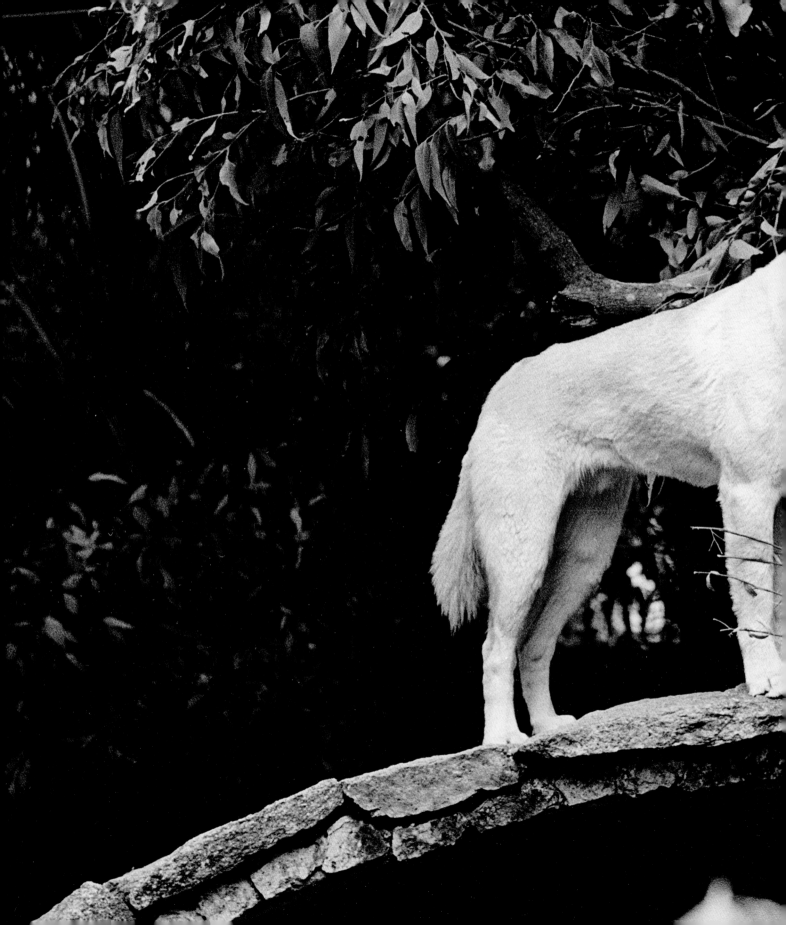

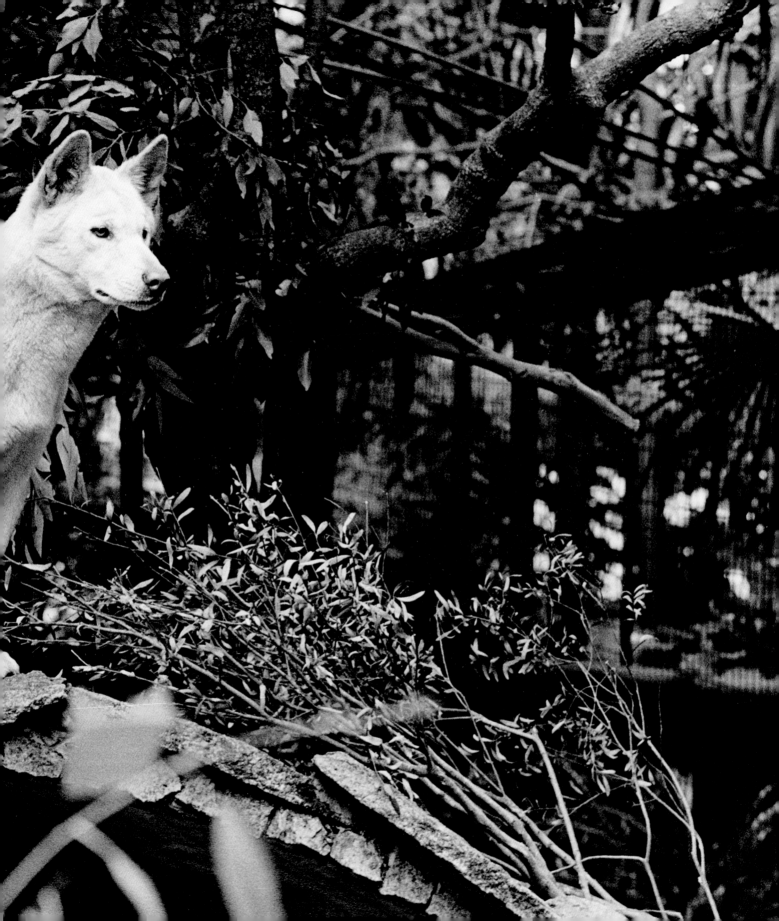

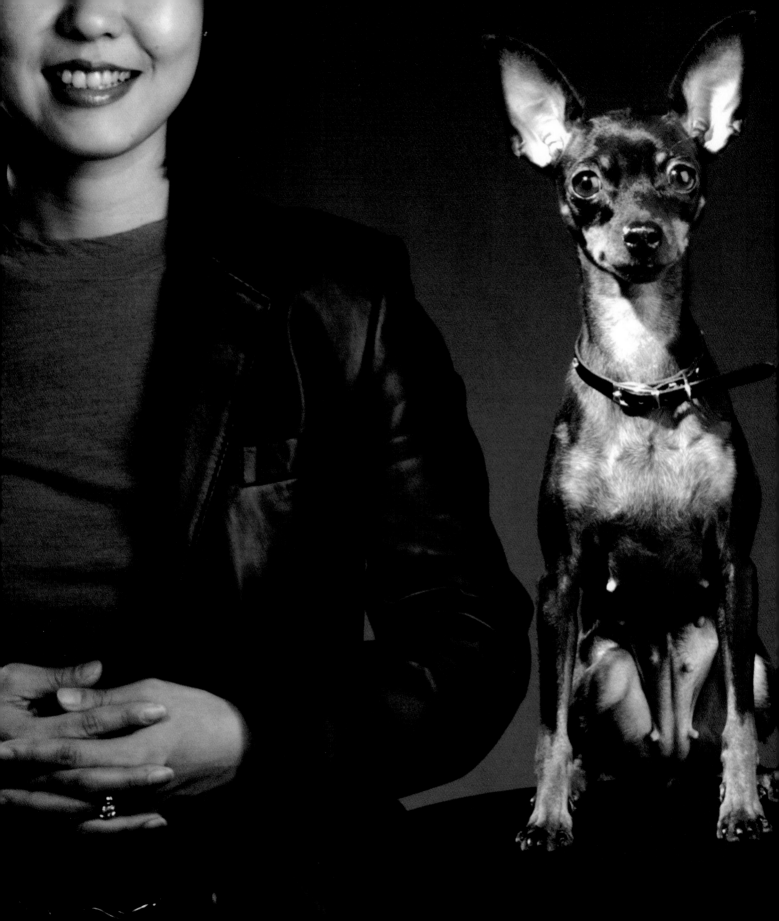

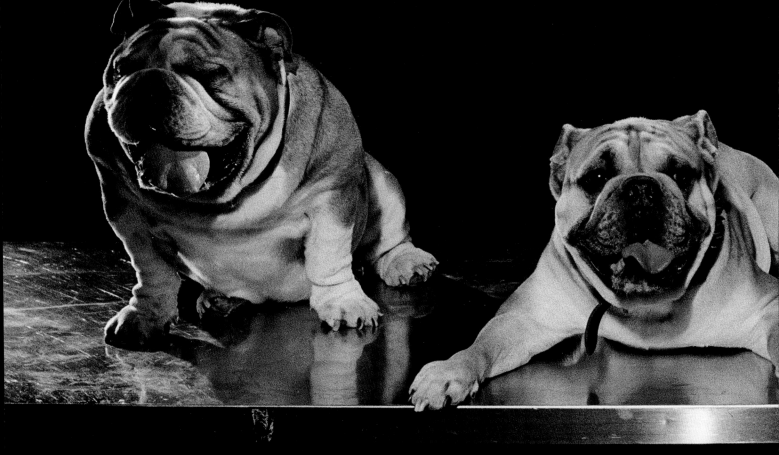

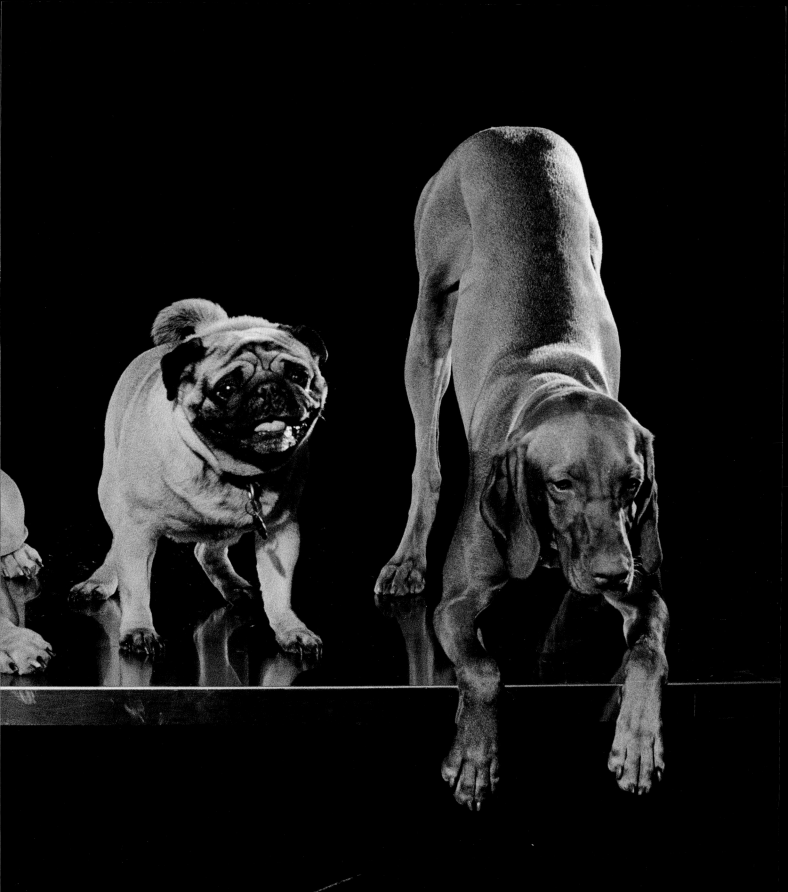

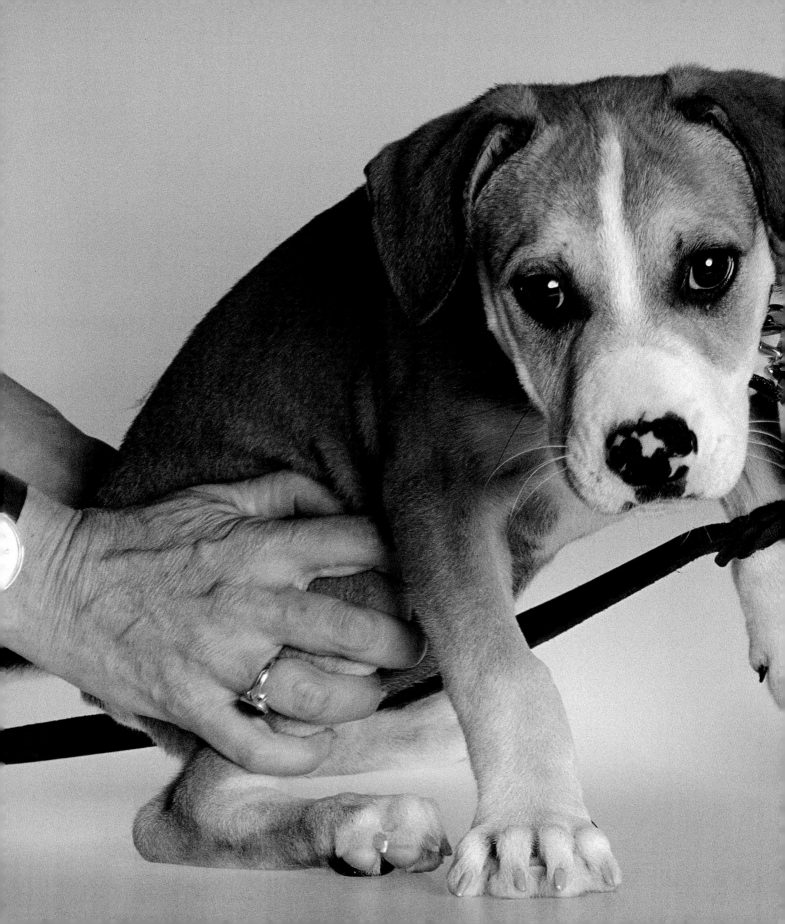

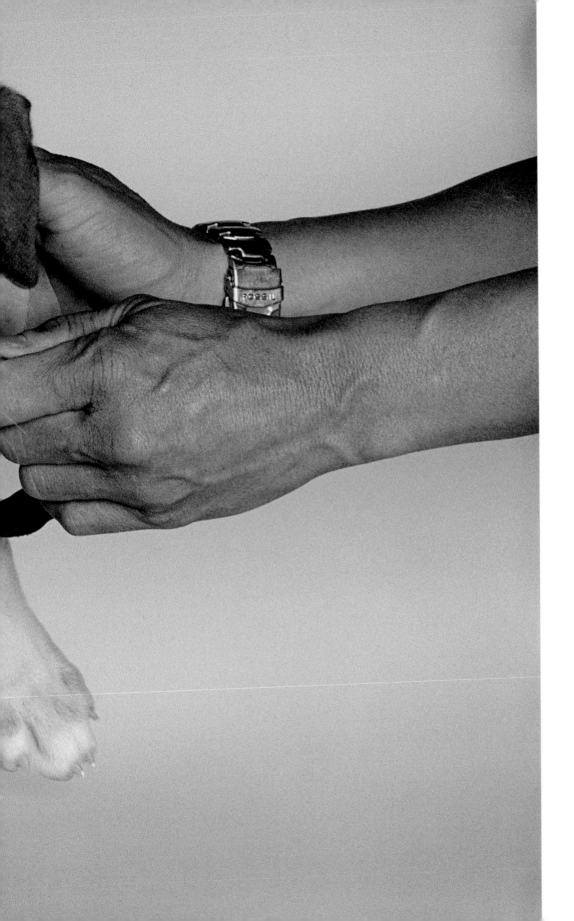

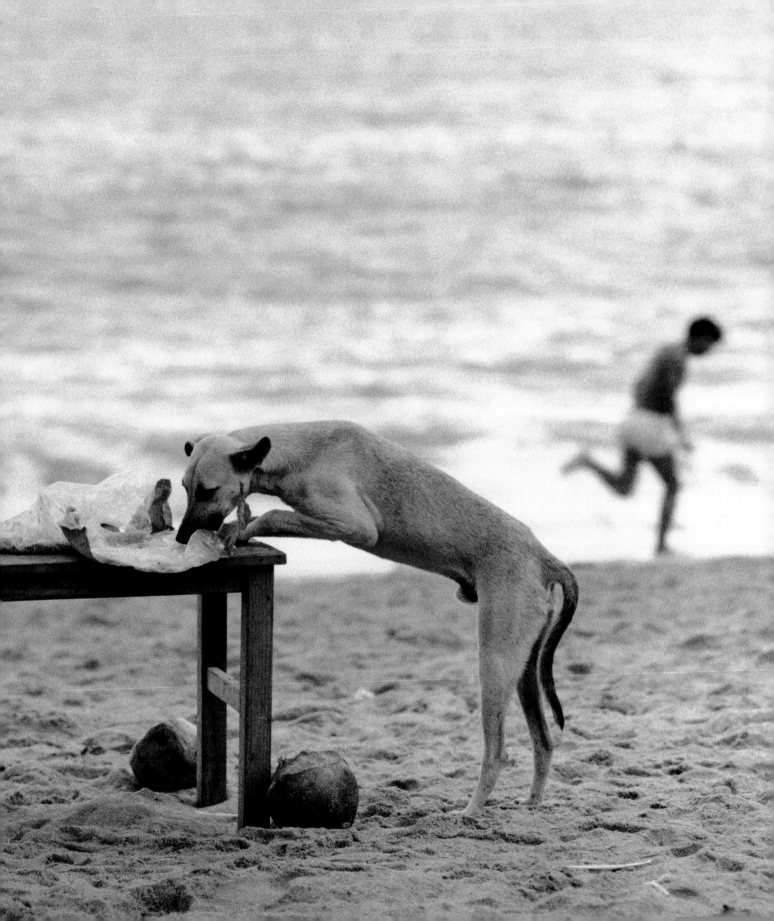

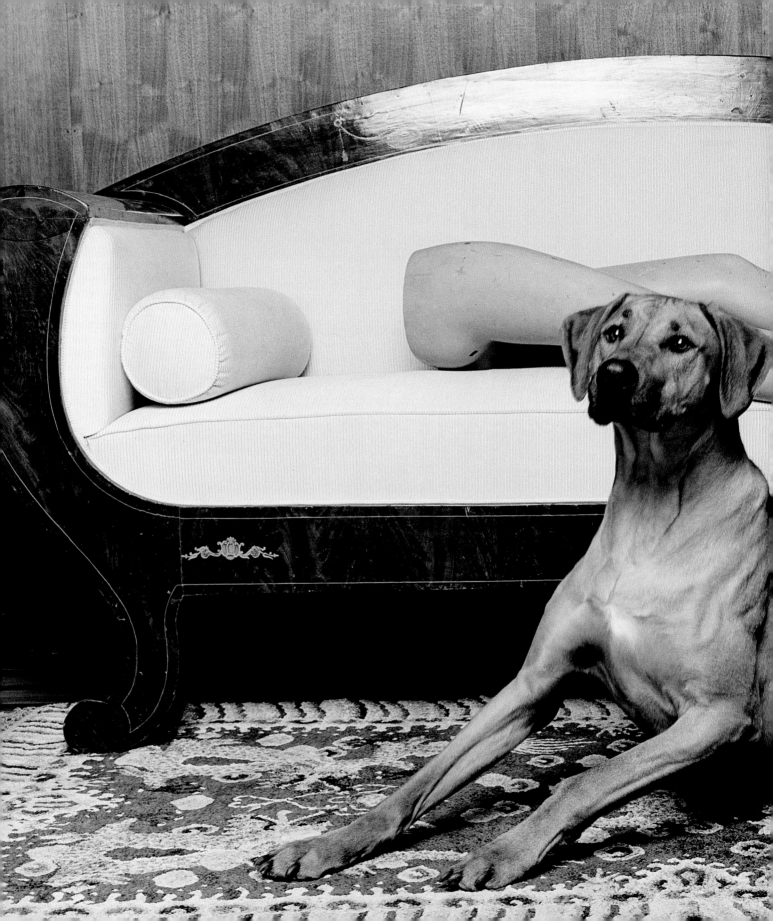

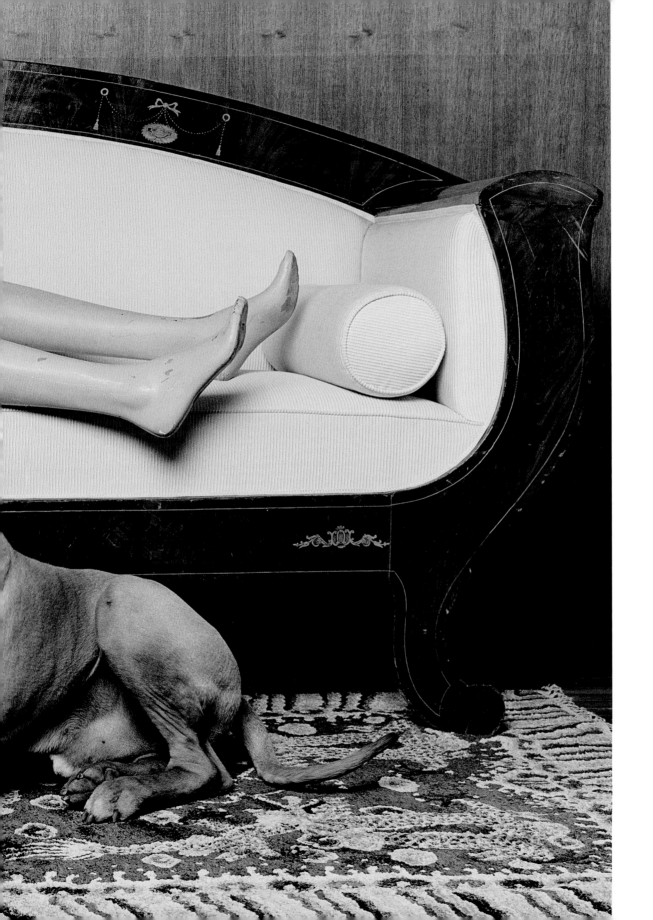

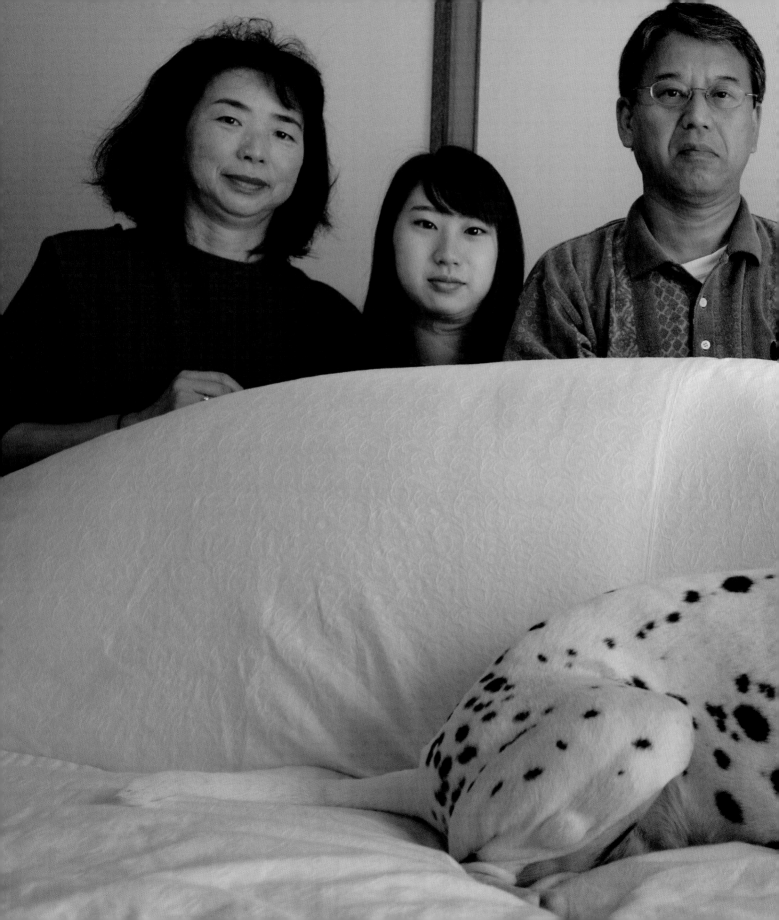

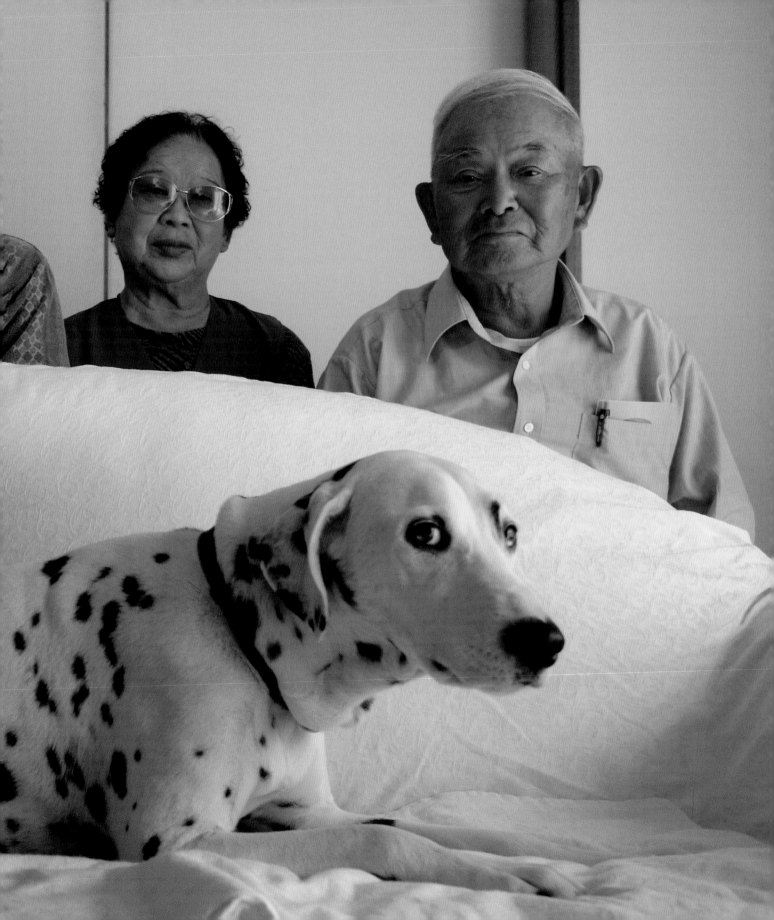

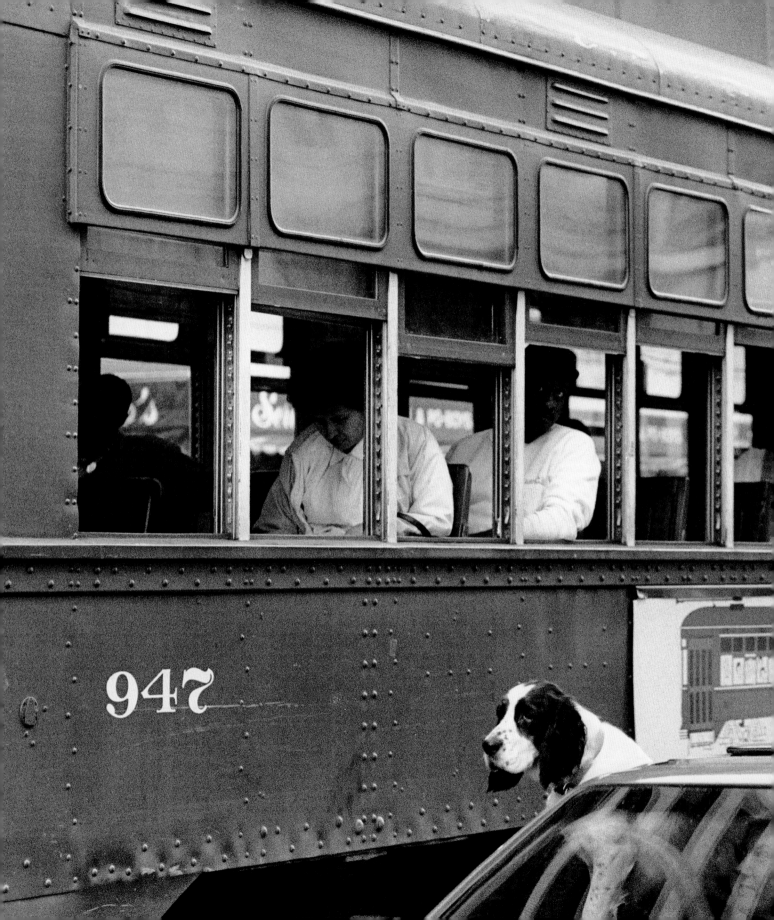

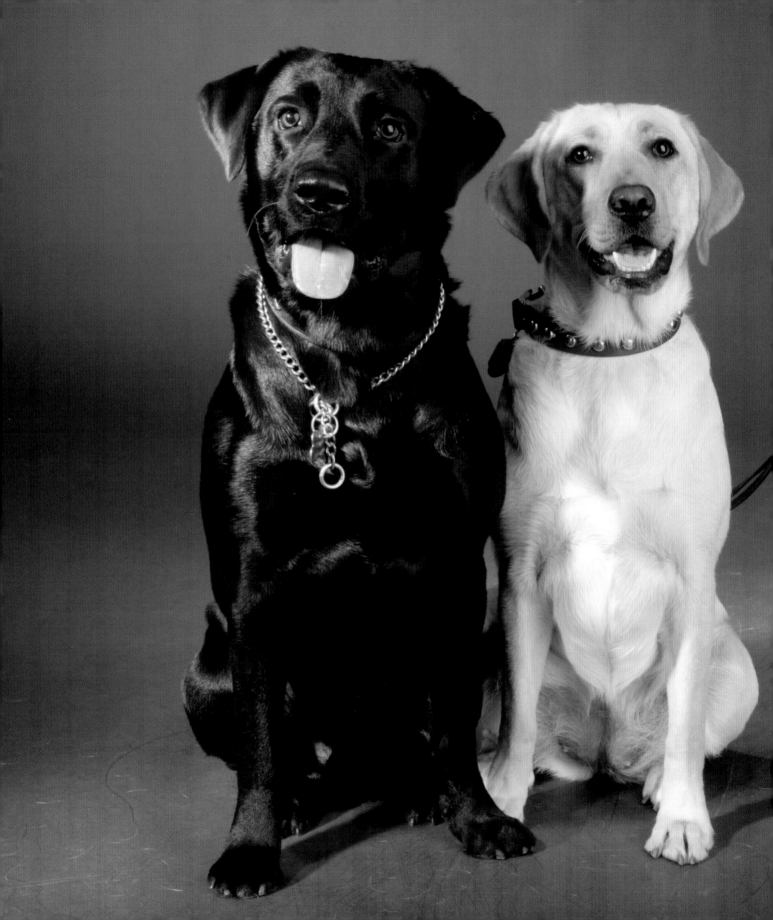

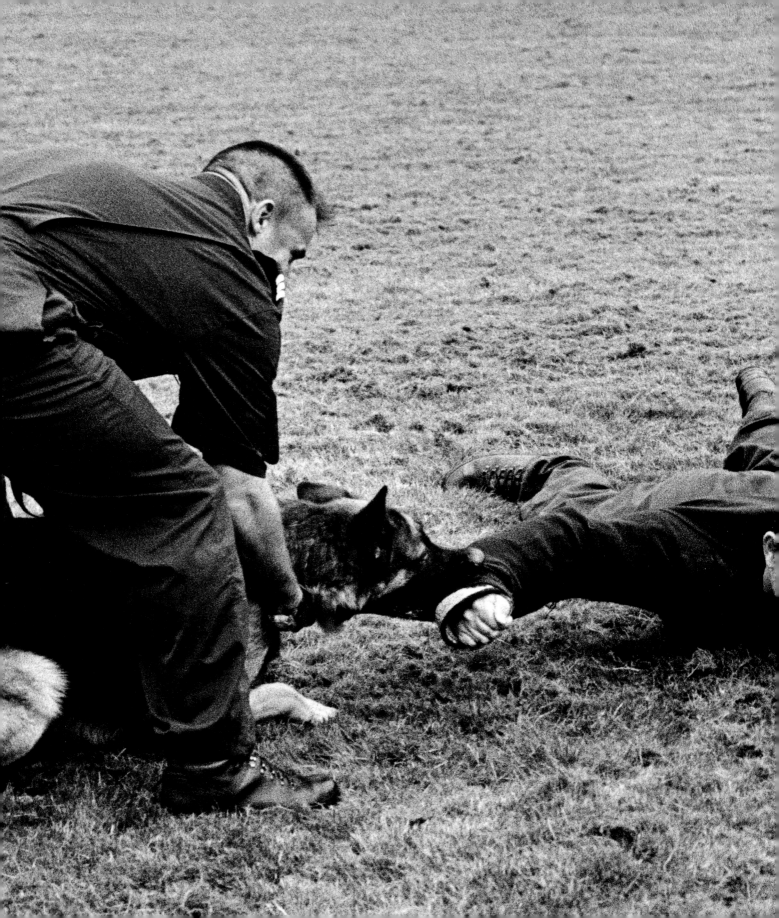

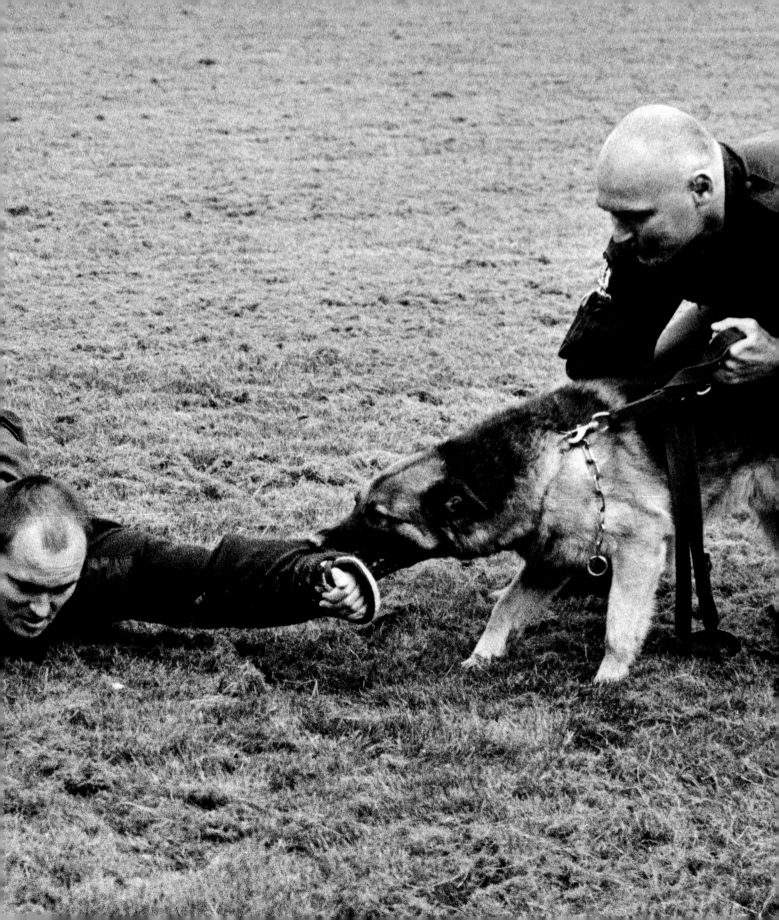

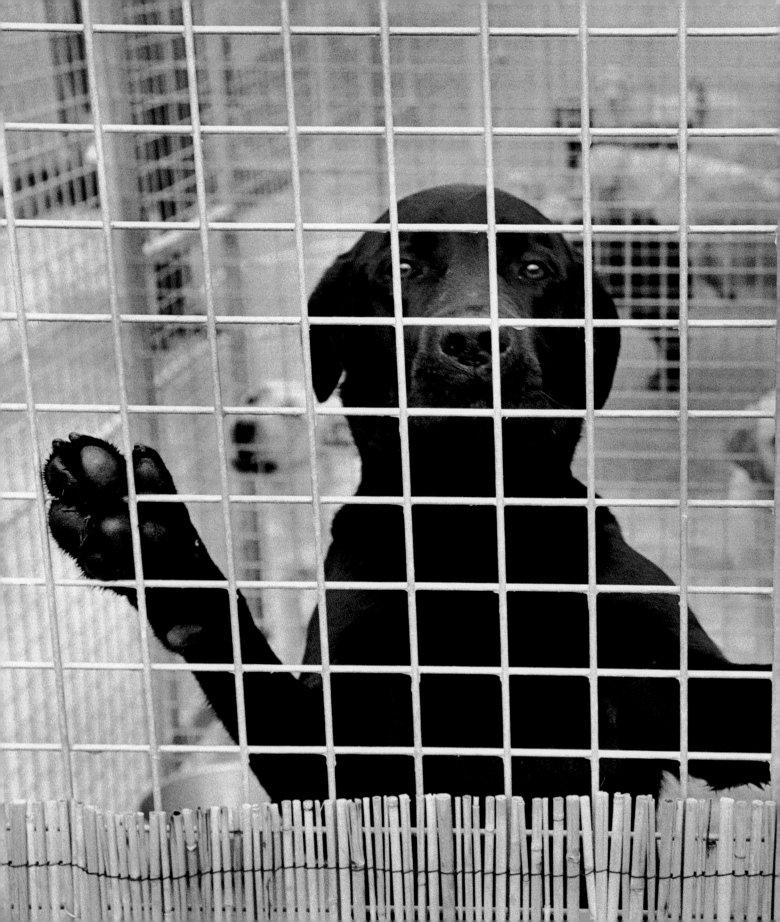

The dog is a yes-animal.

Very popular with people who can't afford a yes-man.

— Robertson Davies

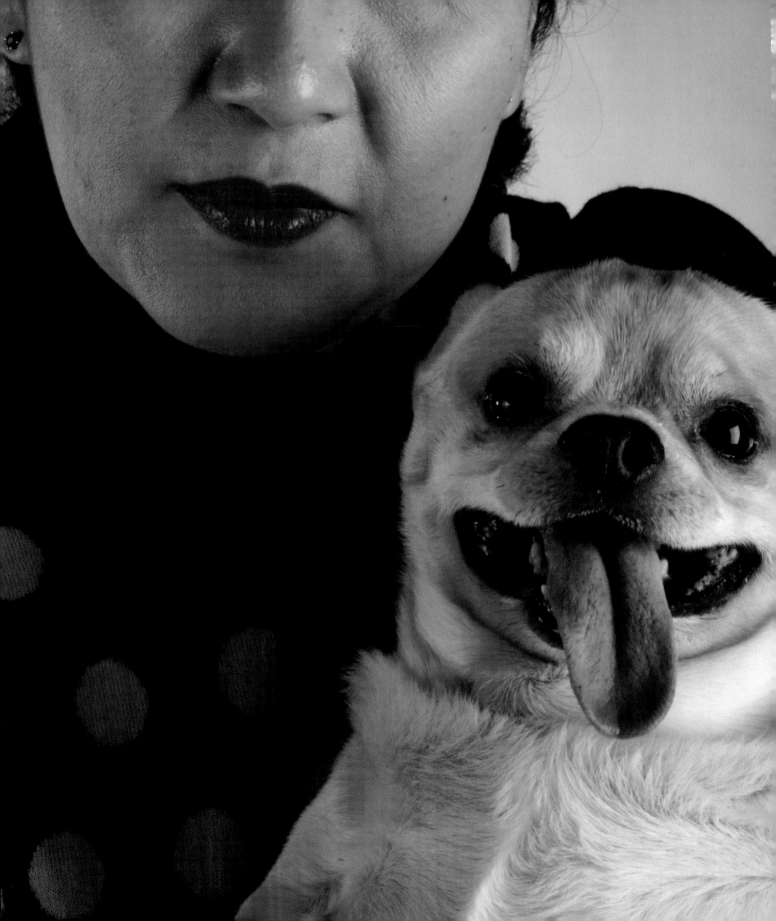

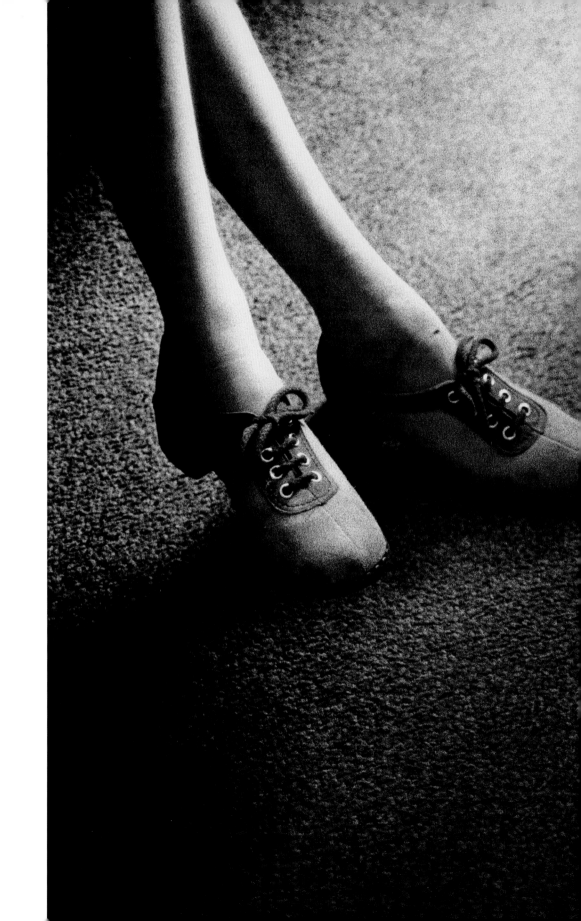

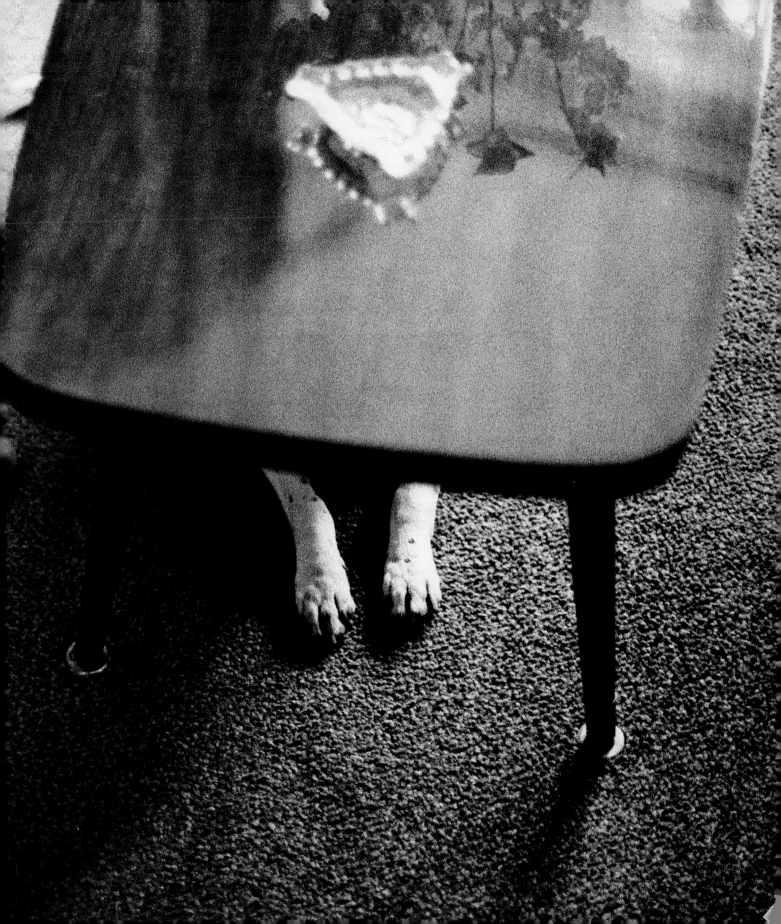

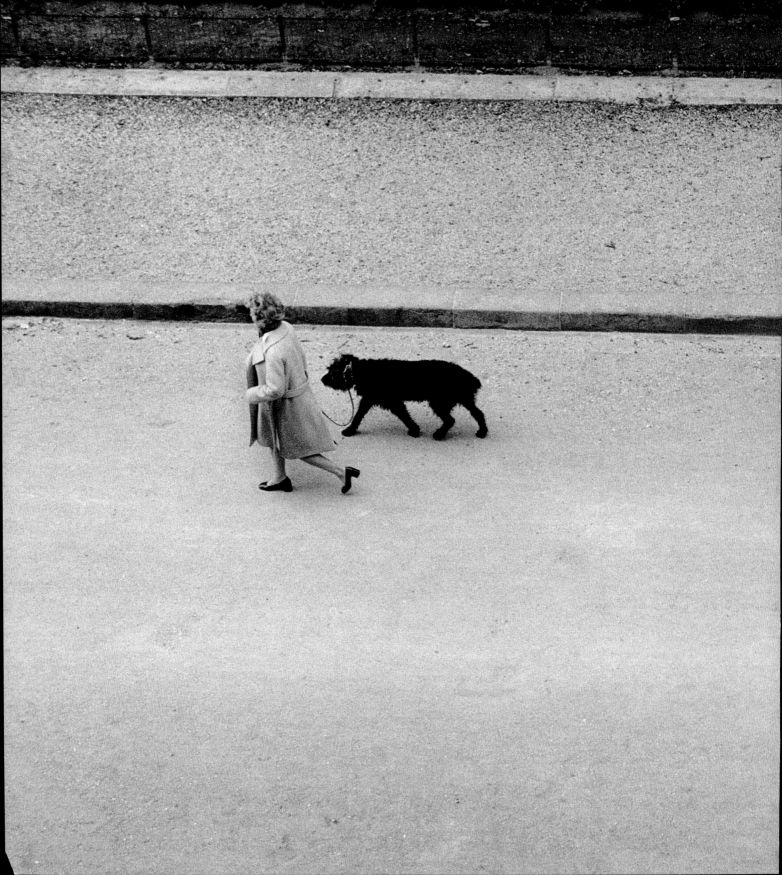

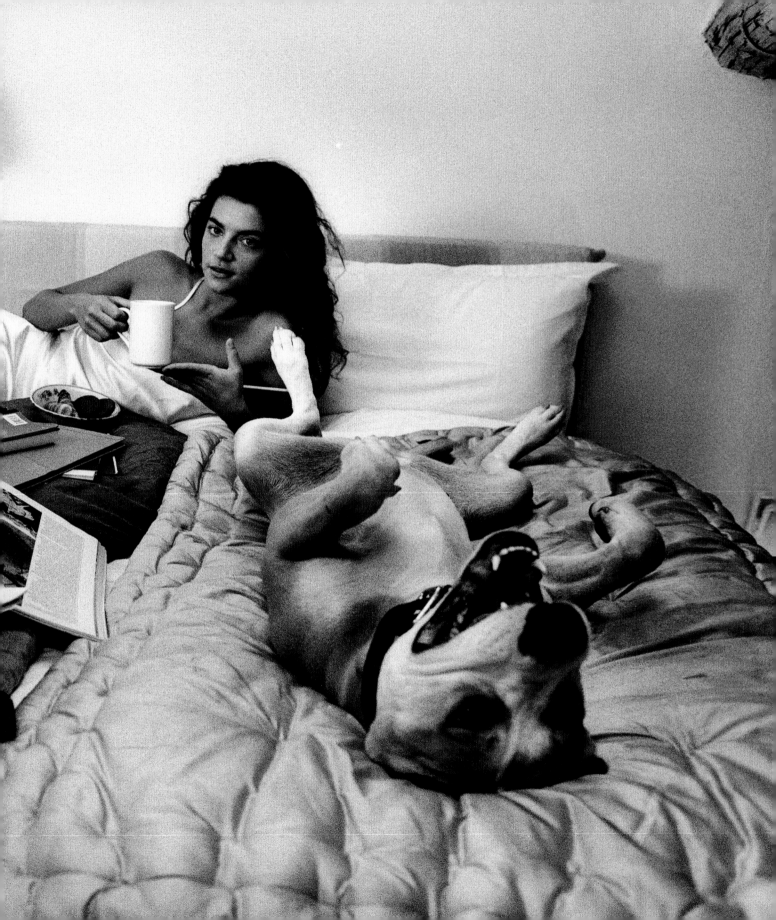

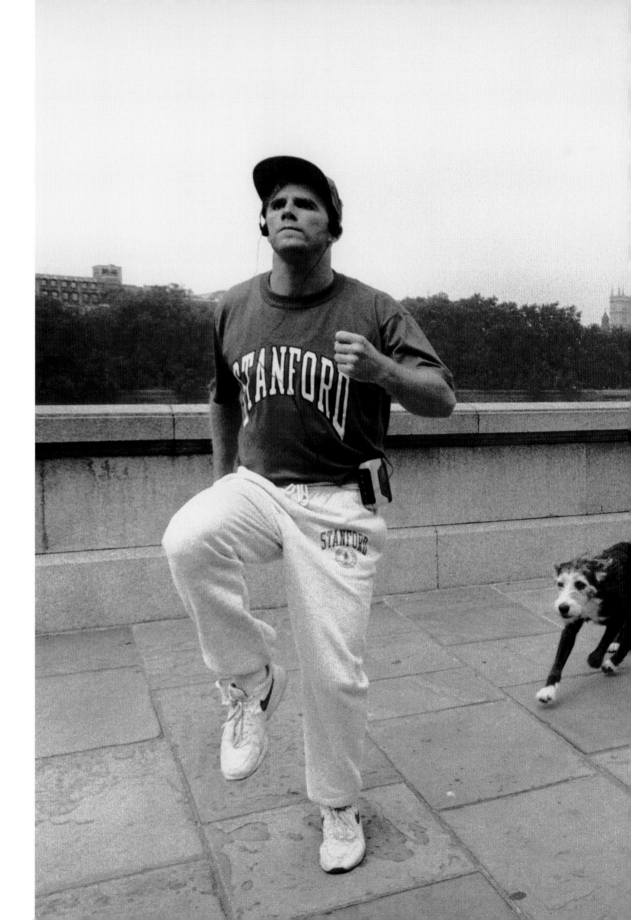

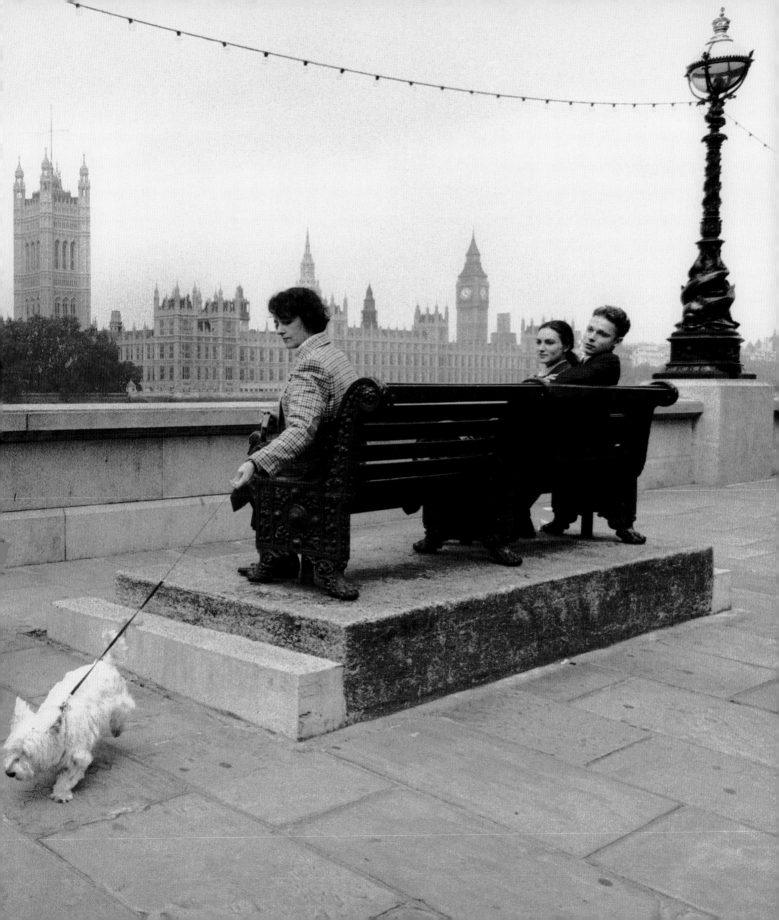

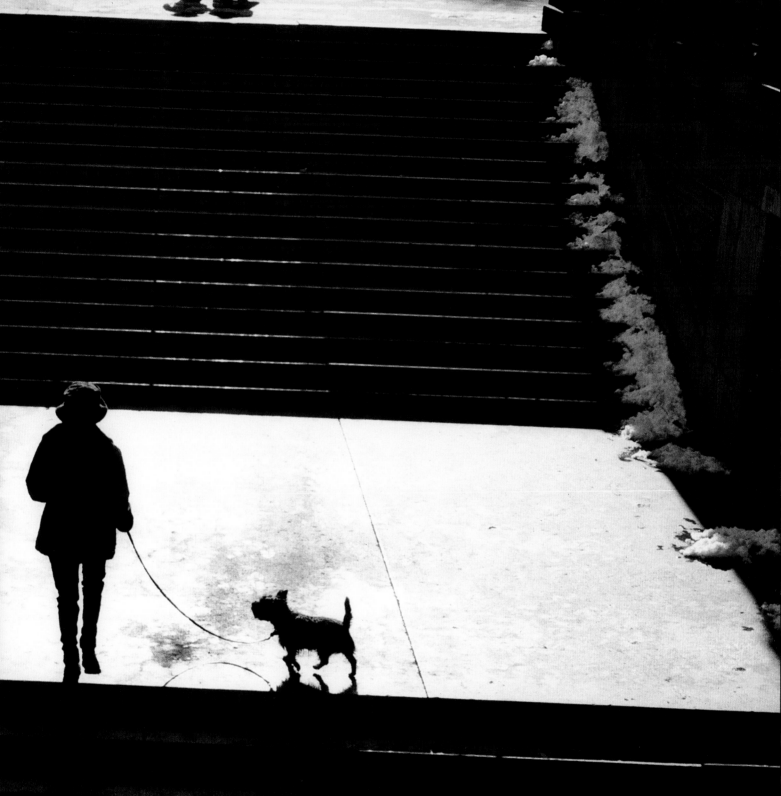

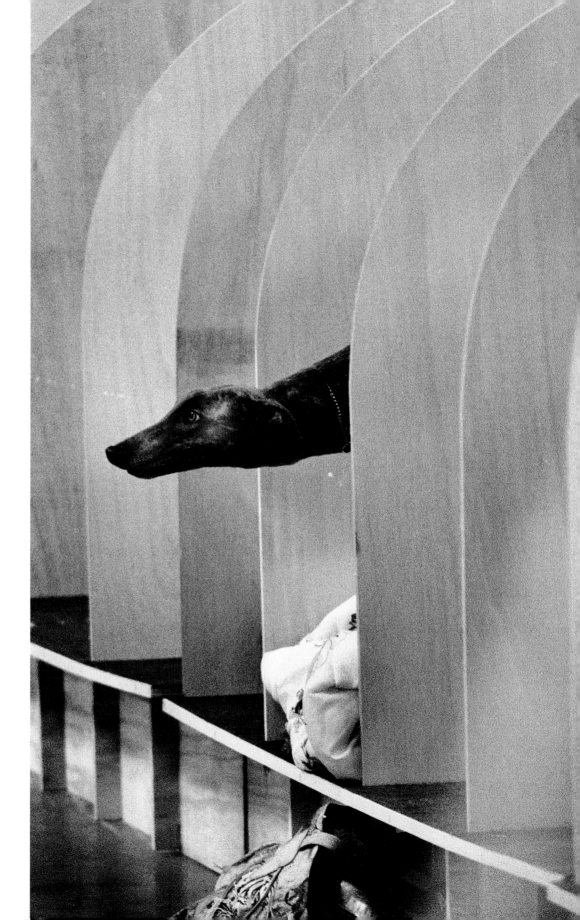

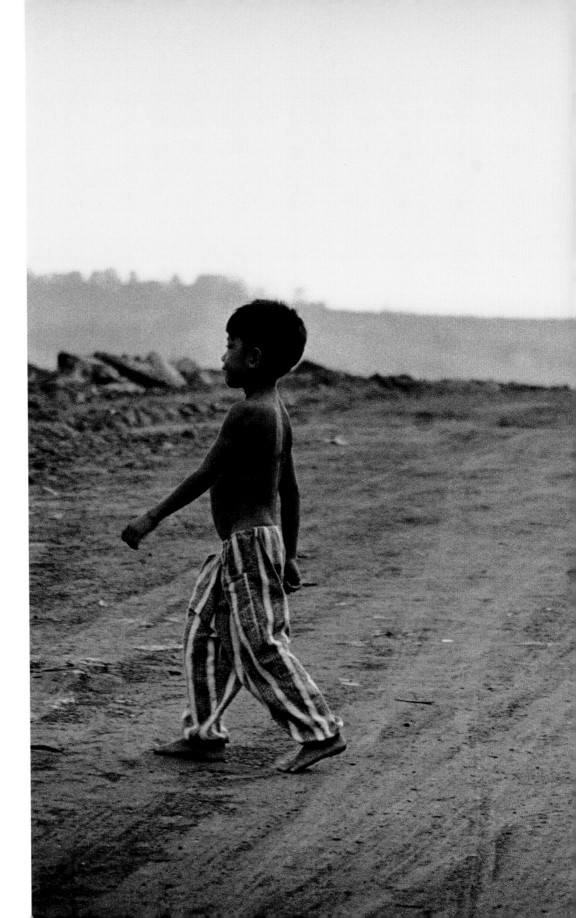

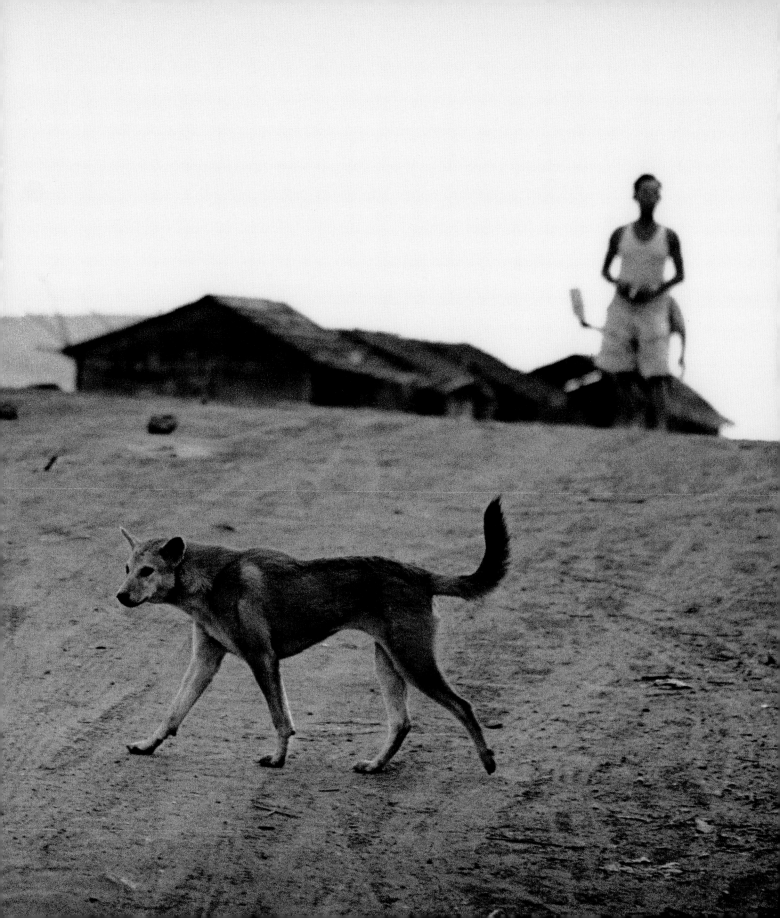

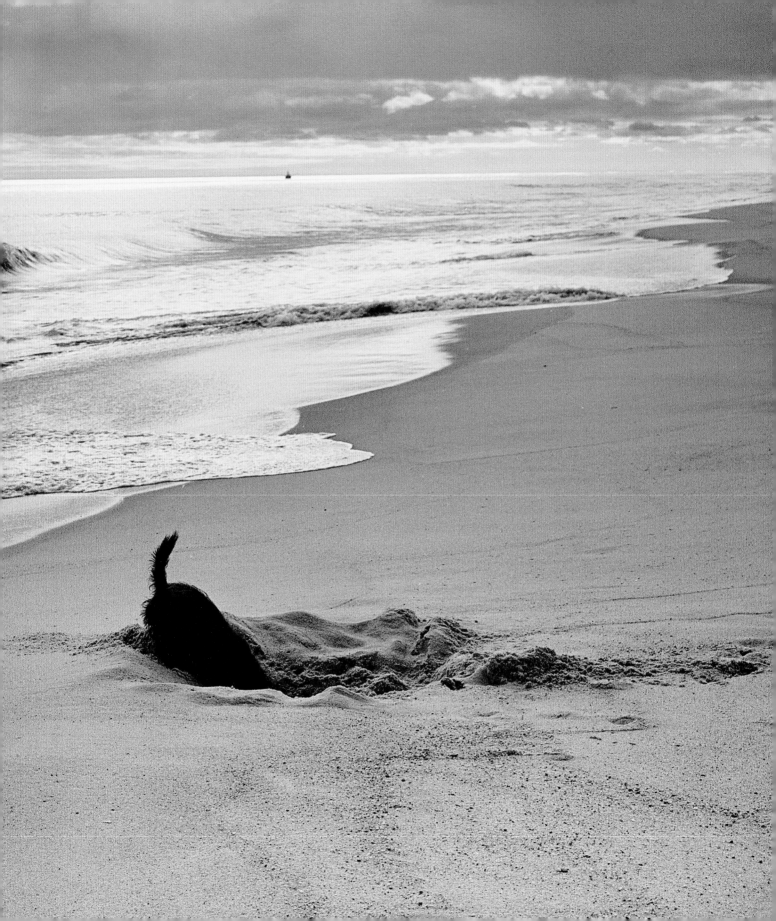

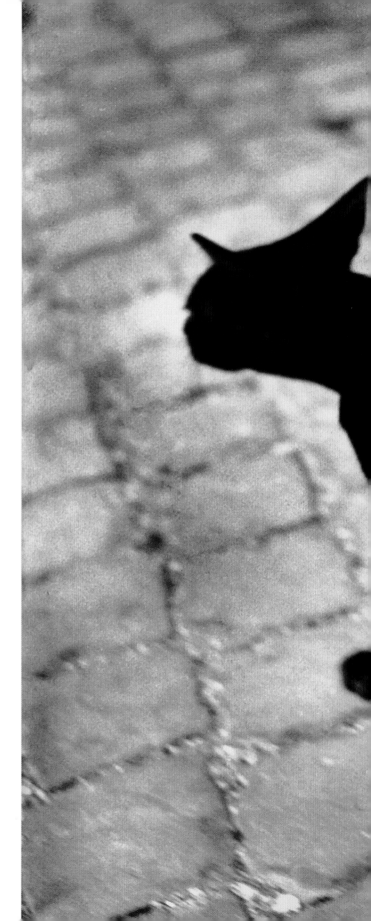

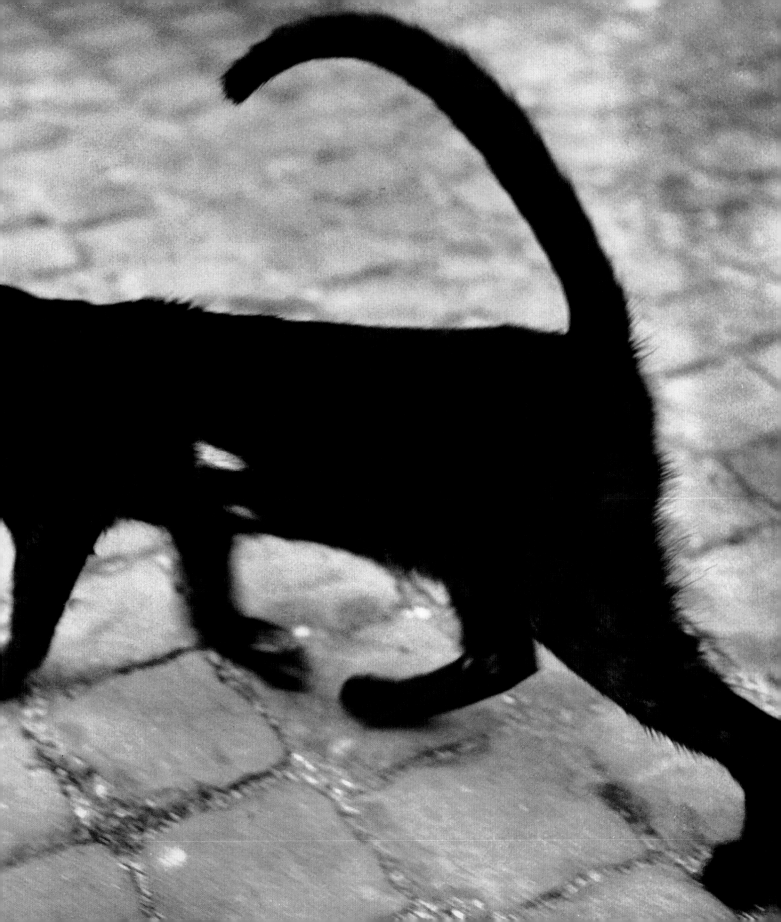

Thoughts on Sammy, Terry, dogs in general, and a Roman cat

Sammy, a frisky Cairn terrier, is the current dog in my life (see pages 96–97). I walk him twice a day in New York's Central Park

when I am not away travelling for work. Sammy and I go out to the park in the early morning and in the late evening. This same routine is applied when we stay near our beach in the country. My wife takes Sammy out afternoons. As good citizens we both go out armed with poop bags. Ours is an easy, uncomplicated discipline, a purposeful but simple ritual in a complicated city that could be compared to a Zen meditation of clearing our minds while Sammy clears his insides.

It is extraordinary how a small, non-human creature can become an integral part of one's life, profoundly affecting one's activities and schedules. The commitment of care is somewhat similar to that toward children, but children grow up eventually and they ask for the keys to the car. Dogs never do; they stay as needy infants totally dependent on us in exchange for their devotion and fidelity.

A first dog is nearly as memorable as a first lover.

My first dog was a bald, cauliflower-eared mutt, a mostly German shepherd mix but fundamentally nondescript. Theobaldo was the name I gave him because of a bald spot on his head. Terry was his functional name (more pronounceable than Theo but less exotic, in keeping with his appearance). Terry was exceptionally sensitive and intelligent in spite of his homeliness, or possibly he compensated because of it. I was thirteen years old during Terry's reign and not yet a photographer, which is why there are no photographs commemorating him in this book. Terry was my emotional rock in troubled times as my parents were battling and divorcing along with all the accompanying domestic disasters. To this day I have kept Terry's precise image alive in my mind, and I fully expect to meet him again in heaven one day.

The pictures in this book are for the most part the result of my hobby of photography. When travelling on assignment and working professionally at my trade, I carry my easily portable, convenient, and personal non-business Leica camera. With it I snap away at whatever tickles my fancy. And largely, along the way, my fancy is tickled by dogs. Generally dogs do not mind or put up a fuss about being photographed. They make no demands for baksheesh, and vanity about appearance is seldom their concern, unlike most of my human subjects. The offer of some of Sammy's cookies, which I often carry in a plastic bag on my dog walks, goes a long way toward striking up fast canine friendships. Most dogs accept my offerings graciously, taking them as a gesture of goodwill.

Dogs can be found everywhere in the world. Barking and whining is their expressive language universally. In my experience, their tones, accents, and timbres differ, as do their racial characteristics and therefore the manner in which I would converse with them. I would not bark at a chihuahua in the same way that I would bark at a farm dog (see pages 112–113) or whine to an aristocratic Russian borzoi (see first page), or as I would growl to an Australian dingo (see pages 114–115), as much out of respect as to communicate.

The reader will probably note a single picture of a seriously different species in this book (see pages 162–163). This may seem out of place among all the dogs and make the person wonder how it got into a Woof book. I offer a personal explanation. For humans who love and appreciate domesticated animals, I believe the world is divided into dog and cat people. As a dog person, I reluctantly believe there may be nearly enough room for both views. Therefore this is my gesture toward fair balance and toward extending my sympathy to all people who care about and rely upon the love and comfort of God's fuzzy creatures. So I offer that skinny, stealthy cat photographed on the grounds of the Pantheon in Rome, a place known for cats that have been breeding and surviving around its perimeter for the past two thousand years.

Breed yet to be determined.

165

And I extend my thanks to all the four-legged friends (see below) that have crossed my path and without whom this volume would not have been possible. I offer my sincere apologies to any dog that may have been inadvertently left out. — Elliott Erwitt

Dignity Payday Igor Graff Happy Boy Buck Molly Strider Chuck Samson Bruno Rube Mickey Lance Rasputin Sabra Bob Odd Flame Dakota Arfy Barky Pal Good Lasa Jerry Precious Maurizio Fred Thalin Junior Siegfried Fritz Sinbad Henderson Robby Flash Moon Keller Bitsy Pooh Ch. Ingo v. Wunschelrute Piggy MacGregor Daisy Toby O'Brien Wolf Snip Dorcas Sam Roberts Troubador Fang Pepe La Knute Roscoe Plato Luke Star Devvy Mutt George Bella Babette Gus Brutus Sheba Jefferson Horace Slave Stony Mush Maybe Rollo Marmaduke Jasper Bowser Tubby Amanda Belle Gemini Tulip Marvin Paddy Dunsan Sport Genevieve Captain Mittens Attaboy Mr. Payday Casey Doughboy Moro Satan Toy …

Missy Sluffy Coony Marty Where-are-you Cubby Puppin Cognac Pluto B. Baby Lad Rory Damit Albert Victoria Natasha King Timahoe Checkers Balto
ence Kelly Posie Cosey Hannibal Chops Bowser Fritzie Blackie Jacob Panchiti Enuk Jessie Gaston Gaspard Toto Sandy RinTinTin Maurice Duchess Lady Sh
chen Chuck Tramp Nutka L'Etoile Shadow King Whitie Lassie Snowball Dogonit Thor Wolfgang Barnabus Wag Beelzebud Trafalgar Emma Dickens W
ter Andrew Demi-tass Beanie Mut Mike Fergus Raquel BamBam Nigel Sheba Taffy Whiskey Brandy Krista Cleo Boliver Lennie Toodles Tootsie Cooch
y Bobtail Black Bart Golly Aikido Saucy Friday Chopper Mister Zipper Shadow Bozo Griffen Jiggsy Queenie Jeff Munch Lilly Jason Blue Alice Frisky S
aulle Maggie Marquis Lucky Trigger Brandt Brownie Daisy Robespierre Major Penny Red Cookie Tinker Porkie Tootsie Binky Ludwig Sarge Henry Cleo
y Prudence Réal Mr. Wu Dickens Shadow Sazzie Cooch Popov Mieza Magot Rosette Semiramis Coquinette Flamence Lotus Trompette Fido Kiki Fout
oo Sam Bosie Doictor Rosie Lulu Charlie Skokie Melvin Tam Chin Colonel Perky Rebel Miura Vodka Harka Arthur Rover Cooch Sarah Pooky Bonny V
hie Snooky Beno Belly Hector Ho-chi Fred Maggin Pounceforth Teobaldo Mattatias Terry Igor Lady Frisky Cindy Brutus Beou Moauer Rex Felix Arthur
nidann Mike Stagel Cheebee Sir Tar Tar Ralph Becky Thursday Aristotle Russell Dusty Ned Fidel Silver Jimminy Bugler Streak Jesse Skipper Cricket Hex
ffy Toledo Marvin Frou Frou Biege on Baby Mosse Cow J. Jones Tiny Duke Downie Sadie Mississippi Samuel J. Pugsley Manchester Guardian Oreo Th
ck Samson Bruno Rube Mickey Lance Rasputin Sabra Bob Odd Flame Dakota Arfy Barky Pal Good Lasa Jerry Precious Maurizio Fred Thalin Junior Siegf
bador Fang Pepe La Knute Roscoe Plato Luke Star Devvy Mutt George Bella Babette Gus Brutus Sheba Jefferson Horace Slave Stony Mush Maybe Rollo
nny Sarg Pugsley Lola Tulip Marvin Paddy Dunsan Sport Genevieve Captain Mittens Attaboy Mr. Payday Casey Doughboy Moro Satan Pride Hamlet Ti
Senior Chien Chipps Bonny Sidecar Amigo Buck Denver Aries Chops Lucretia Adam Leonardo Pansy Solo Speed Casper Freida Pacer Sammy Pico Sir
ie Knee High Smitty Jeff Gum Drop Blackie Esmarelda Kehoe Boojum Champ Schatz Shamus Jason Gypsy Jeana Jamie Homer Rembrandt Misnomer Pa
crombie Star Rocky McTavish McSam Sunny Woofie Pong Puffin Samson Chamois Reddy Herbie Darius Sop Churchill Toy Tiger Bear Max Frowl Clare
oer Cleo Angus Waldo Elmer Ralph Pixie Daiquiri Bullet Jet Spaghetti Radar Chip Peanuts Caboose Bernard Snoopy Sebastian Troubles Pluto Maggie
ones Josh Bruce Louie Scotia Arthur Jordan Sabrina Samantha Panda Bushka Baba Sport Bumble Gaspacho Percival Duffy Fool Confucius Nina Ivan S
ie Tenny Trixie Orestes Louie Sundance Dona Teppy Hushy Taffy Curly Mutsie Ma Ninety Jetsy Sammy Shotsie Cydney Pasquel Tory Smokie Whitney M
Libby Tibby Bach Jolie Poupette Blondie Butter Trixie Laddie Diana Peppy Taffy Elsa Pero Chien D'Or Partou Boy Mister Cindy Slipper Hey You DeC
oy Ladybug Nanette Samantha Rip Oliver Silky Donovan Hobo Yofi Nannie Scratch Sean Suzie Fella Bingo Yetti Alex Honey Boy III Schnorkel Bonnie C
ain Tcholo Tarzan Arthur Chat Kelb Coco Jiggsy Queenie Jeff Munch Pooch Sweeney Piper Chang Vickie Daisy Topsy Dice Muffet Mr. Hoot Soldier Sam
Muffy Gordon Princess Cassius-Emarud Harvey Beauregard Lass Charlie Dude Polonius Hamlet Beowof Heatcliff Xenobia Kuala Pudo Pudipu Poochie
dolph Sadie Smokey Hoot Seneca Lancelot Baudit Spot Fido Butch Hamish Henry Silver Lightening Nathan Woody Gretchen Jande Blaze Furey Hochi
olin Wuli Pip Beebop Burpee Putzchen Ruby Dog Ruff Schroeder Snoopy Ferpo Chuzzie Sunshine Chukka Lucky Quinn Red Big Singer Fenwick Scruf
ip Samson Cardinal Woolsey Belinda Happie Lassie Woof Stinker Jessica Marko Cloud Dignity Payday Igor Graff Happy Boy Buck Molly Strider Chuck
ad Henderson Robby Flash Moon Keller Bitsy Pooh Ch. Ingo v. Wunschelrute Piggy MacGregor Daisy Toby O'Brien Wolf Snip Dorcas Sam Roberts T
maduke Jasper Bowser Tubby Amanda Belle Gemini Pepi Sonny Tiger Marshall Ready Ginger Lady-bug Curry Holly Dolly Happy Annie Golden Boy Sa
er Reb Blue Sonny Soupy Tricksy Come Speed Vet Singer Dobin Hilda Lanyard II Higgens Killer Oslo Sleeper Cuddles Sadie Gabby T Bone Snowball Per
oi One Way Topper Asta Fala King Mohegan Angela Perry Hunter Three Spot Star Dipper Rocket Nails Charlie Chance Archie Soda Pop Mench Flyer
Missy Sluffy Coony Marty Where-are-you Cubby Puppin Cognac Pluto B. Baby Lad Rory Damit Albert Victoria Natasha King Timahoe Checkers Balto
ence Kelly Posie Cosey Hannibal Chops Bowser Fritzie Blackie Jacob Panchiti Enuk Jessie Gaston Gaspard Toto Sandy RinTinTin Maurice Duchess Lady Sh
chen Chuck Tramp Nutka L'Etoile Shadow King Whitie Lassie Snowball Dogonit Thor Wolfgang Barnabus Wag Beelzebud Trafalgar Emma Dickens W
ter Andrew Demi-tass Beanie Mut Mike Fergus Raquel BamBam Nigel Sheba Taffy Whiskey Brandy Krista Cleo Boliver Lennie Toodles Tootsie Cooch
y Bobtail Black Bart Golly Aikido Saucy Friday Chopper Mister Zipper Shadow Bozo Griffen Jiggsy Queenie Jeff Munch Lilly Jason Blue Alice Frisky
aulle Maggie Marquis Lucky Trigger Brandt Brownie Daisy Robespierre Major Penny Red Cookie Tinker Porkie Tootsie Binky Ludwig Sarge Henry Cleo
ence Réal Mr. Wu Dickens Shadow Sazzie Cooch Popov Mieza Magot Rosette Semiramis Coquinette Flamence Lotus Trompette Fido Kiki Foutriquet
Bosie Doictor Rosie Lulu Charlie Skokie Melvin Tam Chin Colonel Perky Rebel Miura Vodka Harka Arthur Rover Cooch Sarah Pooky Bonny Wow Oli
oky Beno Belly Hector Ho-chi Fred Maggin Pounceforth Teobaldo Mattatias Terry Igor Lady Frisky Cindy Brutus Beou Moauer Rex Felix Arthur Miss
nidann Mike Stagel Cheebee Sir Tar Tar Ralph Becky Thursday Aristotle Russell Dusty Ned Fidel Silver Jimminy Bugler Streak Jesse Skipper Cricket He
ffy Toledo Marvin Frou Frou Biege on Baby Mosse Cow J. Jones Tiny Duke Downie Sadie Mississippi Samuel J. Pugsley Manchester Guardian Oreo T
ck Samson Bruno Rube Mickey Lance Rasputin Sabra Bob Odd Flame Dakota Arfy Barky Pal Lasa Jerry Precious Maurizio Fred Thalin Junior Siegfried

per Abercrombie Star Rocky McTavish McSam Sunny Woofie Pong Puffin Samson Chamois Reddy Herbie Darius Sop Churchill Toy Tiger Bear Max F
oi Skipper Cleo Angus Waldo Elmer Ralph Pixie Daiquiri Bullet Jet Spaghetti Radar Chip Peanuts Caboose Bernard Snoopy Sebastian Troubles Pluto Ma
Mr. Jones Josh Bruce Louie Scotia Arthur Jordan Sabrina Samantha Panda Bushka Baba Sport Bumble Gaspacho Percival Duffy Fool Confucius Nina
y Fritzie Tenny Trixie Orestes Louie Sundance Dona Teppy Hushy Taffy Curly Mutsie Ma Ninety Jetsy Sammy Shotsie Cydney Pasquel Tory Smokie Whi
tes Coco Libby Tibby Bach Jolie Poupette Blondie Butter Trixie Laddie Diana Peppy Taffy Elsa Pero Chien D'Or Partou Boy Mister Cindy Slipper Hey
n Peppy Ladybug Nanette Samantha Rip Oliver Silky Donovan Hobo Yofi Nannie Scratch Sean Suzie Fella Bingo Yetti Alex Honey Boy III Schnorkel Bo
et Vulcain Tcholo Tarzan Arthur Chat Kelb Coco Jiggsy Queenie Jeff Munch Pooch Sweeney Piper Chang Vickie Daisy Topsy Dice Muffet Mr. Hoot So
Oliver Kat Muffy Gordon Princess Cassius-Emarud Harvey Beauregard Lass Charlie Dude Polonius Hamlet Beowof Heatcliff Xenobia Kuala Pudo Pu
i Cecilia Randolph Sadie Smokey Hoot Seneca Lancelot Baudit Spot Fido Butch Hamish Henry Silver Lightening Nathan Woody Gretchen Jande Blaze F
niepf Fridolin Wuli Pip Beebop Burpee Putzchen Ruby Dog Ruff Schroeder Snoopy Ferpo Chuzzie Sunshine Chukka Lucky Quinn Red Big Singer Fen
You Tramp Samson Cardinal Woolsey Belinda Happie Lassie Woof Stinker Jessica Marko Cloud Dignity Payday Igor Graff Happy Boy Buck Molly St
Fritz Sinbad Henderson Robby Flash Moon Keller Bitsy Pooh Ch. Ingo v. Wunschelrute Piggy MacGregor Daisy Toby O'Brien Wolf Snip Dorcas Sam Rob
rmaduke Jasper Bowser Tubby Amanda Belle Gemini Pepi Sonny Tiger Marshall Ready Ginger Lady-bug Curry Holly Dolly Happy Annie Golden Boy Sa
Reb Blue Sonny Soupy Tricksy Come Speed Vet Singer Dobin Hilda Lanyard II Higgens Killer Oslo Sleeper Cuddles Sadie Gabby T Bone Snowball Pene
pi One Way Topper Asta Fala King Mohegan Angela Perry Hunter Three Spot Star Dipper Rocket Nails Charlie Chance Archie Soda Pop Mench Flyer
ssy Sluffy Coony Marty Where-are-you Cubby Puppin Cognac Pluto B. Baby Lad Rory Damit Albert Victoria Natasha King Timahoe Checkers Balto Sno
Kelly Posie Cosey Hannibal Chops Bowser Fritzie Blackie Jacob Panchiti Enuk Jessie Gaston Gaspard Toto Sandy RinTinTin Maurice Duchess Lady Shi
chen Chuck Tramp Nutka L'Etoile Shadow King Whitie Lassie Snowball Dogonit Thor Wolfgang Barnabus Wag Beelzebud Trafalgar Emma Dickens W
er Andrew Demi-tass Beanie Mut Mike Fergus Raquel BamBam Nigel Sheba Taffy Whiskey Brandy Krista Cleo Boliver Lennie Toodles Tootsie Cooch H
Bobtail Black Bart Golly Aikido Saucy Friday Chopper Mister Zipper Shadow Bozo Griffen Jiggsy Queenie Jeff Munch Lilly Jason Blue Alice Frisky Soc
e Maggie Marquis Lucky Trigger Brandt Brownie Daisy Robespierre Major Penny Red Cookie Tinker Porkie Tootsie Binky Ludwig Sarge Henry Cleo C
Prudence Réal Mr. Wu Dickens Shadow Sazzie Cooch Popov Mieza Magot Rosette Semiramis Coquinette Flamence Lotus Trompette Fido Kiki Foutri
am Bosie Doictor Rosie Lulu Charlie Skokie Melvin Tam Chin Colonel Perky Rebel Miura Vodka Harka Arthur Rover Cooch Sarah Pooky Bonny Wow O
ky Beno Belly Hector Ho-chi Fred Maggin Pounceforth Teobaldo Mattatias Terry Igor Lady Frisky Cindy Brutus Beou Moauer Rex Felix Arthur Missi Ce
n Mike Stagel Cheebee Sir Tar Tar Ralph Becky Thursday Aristotle Russell Dusty Ned Fidel Silver Jimminy Bugler Streak Jesse Skipper Cricket Hex Schr
oledo Marvin Frou Frou Biege on Baby Mosse Cow J. Jones Tiny Duke Downie Sadie Mississippi Samuel J. Pugsley Manchester Guardian Oreo Thank
son Bruno Rube Mickey Lance Rasputin Sabra Bob Odd Flame Dakota Arfy Barky Pal Good Lasa Jerry Precious Maurizio Fred Thalin Junior Siegfried
ador Fang Pepe La Knute Roscoe Plato Luke Star Devvy Mutt George Bella Babette Gus Brutus Sheba Jefferson Horace Slave Stony Mush Maybe
J. Penny Sarg Pugsley Lola Tulip Marvin Paddy Dunsan Sport Genevieve Captain Mittens Attaboy Mr. Payday Casey Doughboy Moro Satan Pride Ha
e Otto Senior Chien Chipps Bonny Sidecar Amigo Buck Denver Aries Chops Lucretia Adam Leonardo Pansy Solo Speed Casper Freida Pacer Sammy Pi
Bernie Knee High Smitty Jeff Gum Drop Blackie Esmarelda Kehoe Boojum Champ Schatz Shamus Jason Gypsy Jeana Jamie Homer Rembrandt Misnd
per Abercrombie Star Rocky McTavish McSam Sunny Woofie Pong Puffin Samson Chamois Reddy Herbie Darius Sop Churchill Toy Tiger Bear Max F
oi Skipper Cleo Angus Waldo Elmer Ralph Pixie Daiquiri Bullet Jet Spaghetti Radar Chip Peanuts Caboose Bernard Snoopy Sebastian Troubles Pluto Ma
Mr. Jones Josh Bruce Louie Scotia Arthur Jordan Sabrina Samantha Panda Bushka Baba Sport Bumble Gaspacho Percival Duffy Fool Confucius Nina
y Fritzie Tenny Trixie Orestes Louie Sundance Dona Teppy Hushy Taffy Curly Mutsie Ma Ninety Jetsy Sammy Shotsie Cydney Pasquel Tory Smokie Whi
tes Coco Libby Tibby Bach Jolie Poupette Blondie Butter Trixie Laddie Diana Peppy Taffy Elsa Pero Chien D'Or Partou Boy Mister Cindy Slipper Hey
n Peppy Ladybug Nanette Samantha Rip Oliver Donovan Hobo Yofi Nannie Scratch Sean Suzie Fella Bingo Yetti Alex Honey Boy III Schnorkel Bonnie G
ain Tcholo Tarzan Arthur Chat Kelb Coco Jiggsy Queenie Jeff Munch Pooch Sweeney Piper Chang Vickie Daisy Topsy Dice Muffet Mr. Hoot Soldier Sa
Kat Muffy Gordon Princess Cassius-Emarud Harvey Beauregard Lass Charlie Dude Polonius Hamlet Beowof Heatcliff Xenobia Kuala Pudo Pudipu Poc
ilia Randolph Sadie Smokey Hoot Seneca Lancelot Baudit Spot Fido Butch Hamish Henry Silver Lightening Nathan Woody Gretchen Jande Blaze F
niepf Fridolin Wuli Pip Beebop Burpee Putzchen Ruby Dog Ruff Schroeder Snoopy Ferpo Chuzzie Sunshine Chukka Lucky Quinn Red Big Singer Fen
You Tramp Samson Cardinal Woolsey Belinda Happie Lassie Woof Stinker Jessica Marko Cloud Dignity Payday Igor Graff Happy Boy Buck Molly St
Sinbad Henderson Robby Flash Moon Keller Bitsy Pooh Ch. Ingo v. Wunschelrute Piggy MacGregor Daisy Toby O'Brien Wolf Snip Dorcas Troubador

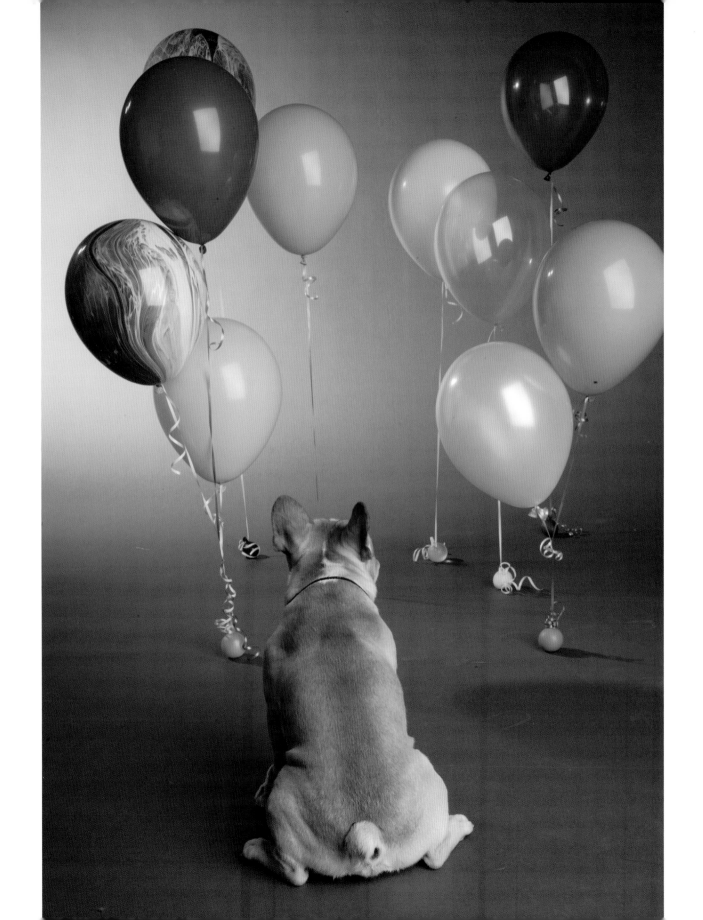

First published in the United States in 2005 by Chronicle Books LLC.

Library of Congress Cataloging-in-Publication Data available.

ISBN 0-8118-5112-5

Manufactured in China

Designed by Kylie Nicholls
Text by Suzanne McFadden

Distributed in Canada by Raincoast Books
9050 Shaughnessy Street
Vancouver, British Columbia C V6P 6E5

10 9 8 7 6 5 4 3 2 1

The publisher is grateful for literary permissions to reproduce those items below subject to copyright. Every effort has been made to trace the copyright holders and the publisher apologizes for any unintentional omission. We would be pleased to hear from any not acknowledged here and undertake to make all reasonable efforts to include the appropriate acknowledgment in any subsequent editions.

Dogs love company. They place it first in their short list of needs. Extract from *My Dog Tulip* by J.R. Ackerley, published by New York Review of Books (USA) and Granta Books (UK and Commonwealth). Reprinted by permission of David Higham Associates.

Chronicle Books LLC
85 Second Street
San Francisco, California 94105

www.chroniclebooks.com